Art with an iPhone

Kat Sloma

AMHERST MEDIA, INC. ■ BUFFALO, NY

About the Author

Kat Sloma is a fine art photographer, writer, and instructor who developed her distinct contemplative style when she began using an iPhone to create photographic art. Her iPhone work has received recognition in the U.S. and internationally. A believer that everyone has the potential to share a unique point of view through art, Kat writes, teaches workshops, and speaks about the iPhone and other creative aspects of photography. She is the author of the popular eBook *Digital Photography for Beginners: Understanding Exposure, Light, Composition, and Using Your DSLR* and The Kat Eye View of the World blog. Kat currently lives in Corvallis, Oregon, with her husband and son. To see more of Kat's work, visit www.kateyestudio.com.

Published by:
Amherst Media, Inc., P.O. Box 586, Buffalo, N.Y. 14226, Fax: 716-874-4508
www.AmherstMedia.com

Publisher: Craig Alesse
Senior Editor/Production Manager: Michelle Perkins
Editors: Barbara A. Lynch-Johnt, Harvey Goldstein, Beth Alesse
Associate Publisher: Kate Neaverth
Editorial Assistance from: Carey A. Miller, Sally Jarzab, John S. Loder
Business Manager: Adam Richards
Warehouse and Fulfillment Manager: Roger Singo

ISBN-13: 978-1-60895-977-8
Library of Congress Control Number: 2015944882
Printed in The United States of America.
10 9 8 7 6 5 4 3 2 1

www.facebook.com/AmherstMediaInc
www.youtube.com/c/AmherstMedia
www.twitter.com/AmherstMedia

Contents

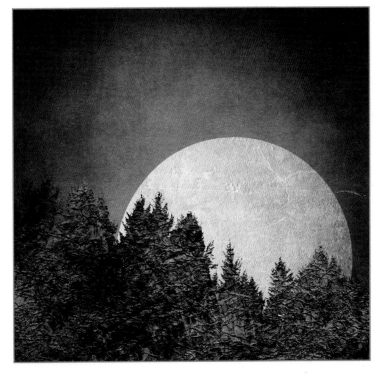

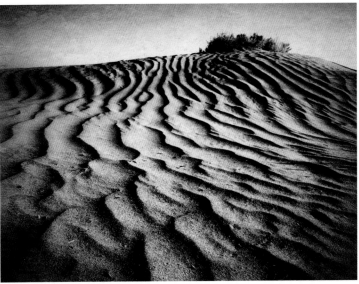

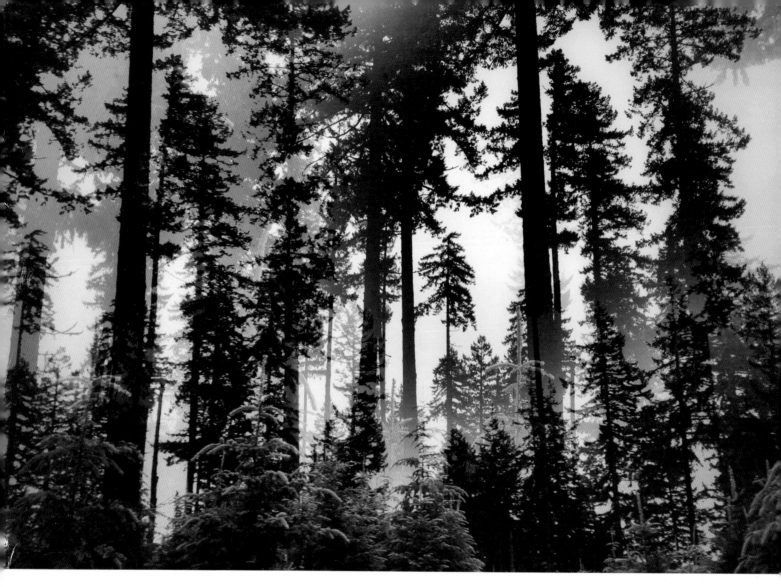

About This Book

If you have an iPhone, you have an amazing creative device in your pocket. Not only is it a convenient and capable camera, it has the tools to transform your photographs into something surprising and unique. With a few dollars in apps and a little bit of time, you can create distinctive art with your iPhone.

In writing this book, I hope to share the fun and excitement I've experienced with capturing photographs and creating photography-based art with my iPhone and iPad. My approach is a simple one. When I am out and about, I seek to capture the best photographs I can using only the iPhone and natural light. (This is the "reality" piece of "Altered Reality.") There is something magical about always having a camera in your pocket. You see the familiar world anew.

Later, when I have time to experiment and play, I use apps to transform the photographs. (This is the "altered" part of "Altered Reality.") I have no rules or expectations of outcome when I sit down to work with my photographs. An image may stay looking like a photograph, or it may become something more abstract. You'll see both in the book. The enjoyment is in seeing what appears as I change an image, altering its tie to reality, through a combination of apps.

The process I share in this book goes beyond the specifics of the device and apps. As with any book that relies on technology, the specific features of the iPhone and the app screen shots will quickly become outdated. The good news is that even through multiple Apple devices and iOS revisions, I've found the apps function similarly and my general approach remains the same. You will be able to apply the information in this book regardless of the specific device or version of operating system you currently use.

For each section in this book there is a primary image, and I've attempted to list all of the apps used in the processing of these images so you can see what can be created when apps are used in combination on photographs. It's quite a range!

Now you know where I'm coming from. Let's get you started creating your own photographic art on the iPhone.

Kat.

Understanding the Hardware

The iPhone adds a new dimension to photography. Unlike previous photographic devices, where the camera was solely a capture device and images were processed later in a darkroom or on a computer, smart-phones and tablets integrate both camera and processing capabilities into one device. While this integration provides an incredibly powerful platform for photography, it also creates challenges because these devices are not intended primarily to be cameras. These first few sections will address some housekeeping issues that arise when using an iPhone for photography, before getting into the camera and apps.

Functionality

In creating a mobile device such as an iPhone, hardware manufacturers must trade off the size, space, cost, and functionality of the camera against other requirements, functions, and end-user expectations. Sensor resolution, sensitivity, lens, and other camera specifications change from device to device (iPhone, iPad, iPod Touch), generation to generation (iPhone 5, 5S, 6, and so on), and even front to back within a device. As such, the cameras in mobile devices are simple, small, and vary greatly by device—even within Apple's lineup of similar devices.

Camera

If you don't know the camera specs for your specific device, look them up. Wikipedia and other online sites are a great source. Knowing the resolution difference between the front and back cameras enables you to make informed trade-offs when you take photographs. If you are debating a purchase, I recommend you look closely at the differences between the camera hardware on the different devices you are considering in order to understand the impact of your choice. These devices may look similar on the outside, but the camera you are getting inside may be quite different.

Even though there are quality and performance trade-offs, one bonus of the simple iPhone camera is ruggedness. These devices are made to be handled, and there is not much you need to do care for the camera. Invest in a simple case to protect it from damage from drops. To clean the lens, use a soft microfiber cloth. To prevent damage to the lens from scratches, tuck the phone into its own pocket without other objects (like keys) or place it with the camera facing away from other items. Use caution when your device is near water and other liquids, such as in the bathroom or kitchen.

While the iPhone is remarkably rugged, you might still consider getting an extended warranty that covers accidental damage. Take it from someone who has dropped an iPhone into a sink of soapy water: the cost of the extended warranty was worth it.

▲ Simple camera kit: an iPhone, case, and microfiber cloth.

Under the Surface ● ProCamera, Distressed FX, AutoPainter, Glaze, Image Blender

2 | Power Management

I like to call my iPhone a "camera with a phone attached to it," but it's not the same as a dedicated camera. With my previous cameras, power management was as simple as getting into a routine of charging the battery after use and keeping a spare charged battery in the camera bag. I could easily go out for a day of intense photography without worrying about running out of power. With my iPhone, power management is not so simple. If I take only a few photos through the course of the day, I don't have to worry about power consumption. If I am photographing continuously for an extended time, however, my battery is likely to be dead within a couple of hours.

Why would that be? Part of it is the power consumption that comes from continued, active use of the touch screen, but it's also because iPhones are much more than a camera. They are GPS, phone, Internet connection, gaming system, word processor, and more. Running apps, searching for connections, providing turn-by-turn directions, and using the touch screen all take power. In order to conserve power for photography, and improve battery life in general, there are a few simple steps you can take.

Close Apps

First, close apps you are not using. When you switch from one app to another, apps stay open in the background, waiting for you to return and pick up where you left off. Apps running in the background increase power consumption, especially ones that use GPS and location services. To close apps, double tap the home button and flick the app up.

Turn Off Bluetooth and Wi-Fi

Second, turn off connectivity features you are not using. Turn off Bluetooth and Wi-Fi if you are not actively using them. If you can manage to live without your cellular connection, put your device in Airplane Mode. This can be done through the iPhone Settings app, but a quicker method is to flick up from the bottom of the screen to get the Quick Access menu. Simply tap the icons to turn connections and services on/off.

Carry a Backup Battery

Third, carry a backup battery. Even after taking all of these precautions, if you are photographing continuously for several hours without access to a wall socket,

▲ Close apps.

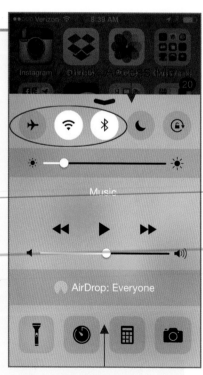
▲ Turn off systems.

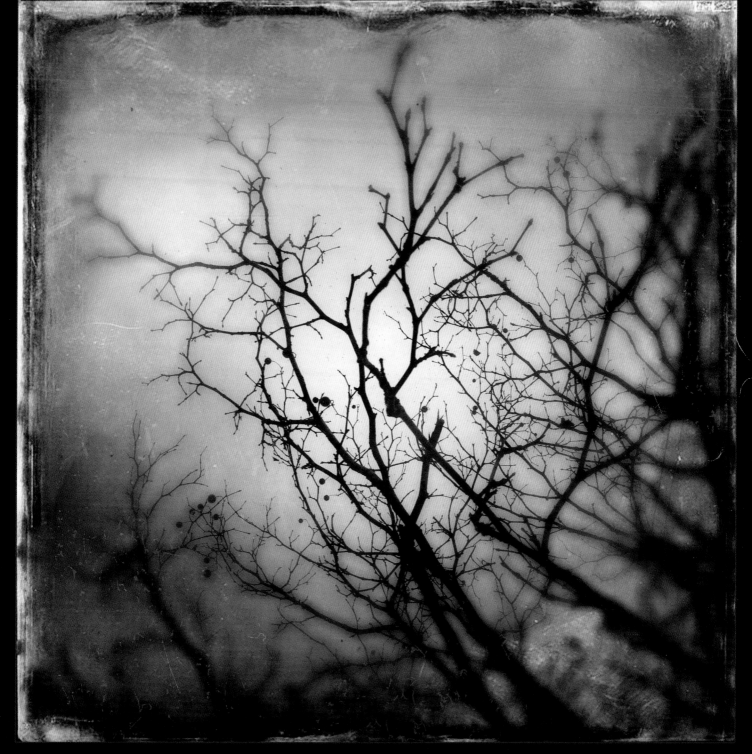

Possibility ● ProCamera and Stackables

a backup battery can be a savior. There are all sorts of backup batteries available for iPhones, from cases with integrated battery packs to standalone batteries in various sizes. When I'm going out to photograph, I carry a small backup battery that fits in the palm of my hand and can charge my iPhone two or three times if needed.

Transferring Files Between Devices

For editing, you might find the iPhone screen is a bit small and you'd rather work on the larger screen of an iPad. To do this, you will need to transfer image files between devices. When transferring files between devices, my goal is to move only the best images to the second device, in order to easily find the photos I intend to edit. I may take a hundred or more photos on a given day with my iPhone but decide I only want to edit a few. I also prefer to review the images on the larger screen of the iPad before I transfer, so that I can see the detail and choose the best version for editing.

I have tried many different transfer methods, from iCloud to various photo transfer apps, and have boiled it down to two methods: one for when both devices can connect to the cloud (Internet) and one for when they can't.

Method 1: Cloud Connected Transfer

Moving images through the cloud via Dropbox is my preferred method of transfer. I transfer all photos from my iPhone to my Dropbox account via the Auto Camera Upload function of the Dropbox app. Then I review the uploaded images using the Dropbox app on the larger screen of the iPad. When I see an image I want to edit, I only download that specific image to the iPad. This reduces file proliferation by moving just a few files out of many. When my Dropbox account reaches its storage limit, I clear out the Camera Uploads folder and start again. I consider the cloud storage a temporary transfer location. Since Dropbox has apps for most operating systems, this method also works well if you want to transfer files between iOS, Android, or other types of devices.

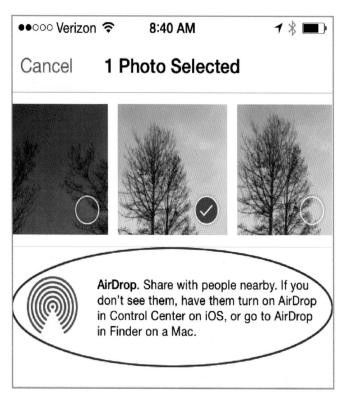

▲ Select photo and export to AirDrop.

Method 2: Without Cloud Connection

When I don't have a connection to the cloud on both devices, Apple's AirDrop is a slow but useful method to transfer files between Apple devices. Start by turning AirDrop's "discoverable by" setting to "everyone" for both devices using the Quick Access menu. Next, go to the Camera Roll of the sending device and select the image(s) you want to export and tap the Export icon. When the Export menu opens, tap the AirDrop icon. The sending device will search for other nearby devices, and will show an icon for each one found. Tap the icon for the device you want to send to, and the photo(s) will be transferred.

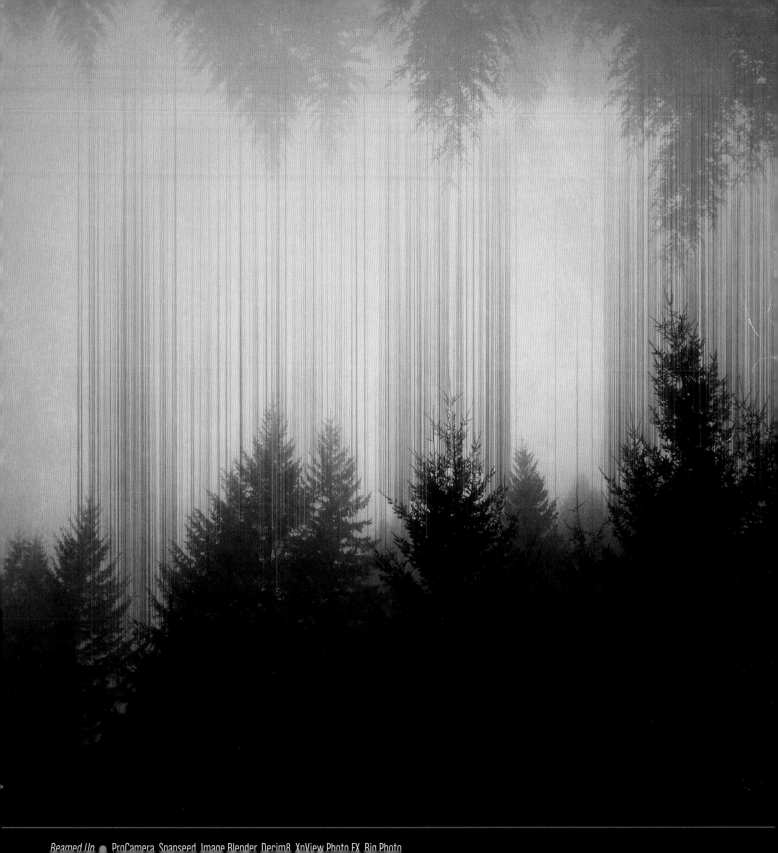

File Management and Storage

I f you have enough space, it might be easy to consider your iPhone as a reasonable place to store your image files long term, but you shouldn't. Your iPhone isn't the same as a computer archive, since it can be more easily lost or damaged. (Remember I dropped my iPhone into the sink?) It also becomes difficult to find specific images when you have a large number of images on your Camera Roll. Photography apps can become sluggish or crash when the Camera Roll gets too large. Having six thousand (or more) photos on your Camera Roll is too many—I've learned from experience. Don't go there.

iPhone as Working Storage

Think of the iPhone as *working* storage. Capture, edit, and share on the device, but move your image files to a computer for permanent backup. I try to keep the num-

ber of image files on my devices under a thousand. This keeps apps functioning well, and I can still find specific files I want in the Camera Roll. I rest easier knowing my older images are safely archived on the computer, which has both local and cloud backups. I can always transfer images back to my iPhone for editing, as desired.

Transferring Files to a Computer

To transfer files between your iPhone/iPad and a computer, connect the device with a USB cable and access it as you would any external storage device. Make sure your iPhone is *not* in the middle of a sync with iTunes before you attempt to do any file manipulation. Wait until the sync completes, eject the iPhone in iTunes, and then proceed with the instructions below.

In Windows, you will be able to access the device through Windows Explorer. Look for the device name, navigate to the Internal Storage folder, and then to the DCIM folders below. Your images and videos reside in the cryptically named folders below DCIM. When you open the folders with the image files, click to select images, then right-click to copy them to a new location (or delete). Use Ctrl-A to select all files in the directory for copying or deleting. You will not be able to delete the directories, just the files.

On a Mac, go to your Applications folder and open the Image Capture app. In the devices column on the left, you will see your device. Select the files of interest to import or delete.

Management in Lightroom

If you are a photographer already using Lightroom for your photo management, integrating the iPhone into your workflow is easy. Attach the device to a computer via the USB cable, then select the device in the Import

▲ Navigating to your images on a Windows PC.

▲ Navigating to your images on a Mac.

dialog window. You can import images as you would from any other digital camera.

Transferring via Dropbox

If your computer is connected to your Dropbox account, transferring through the cloud via Dropbox will also work for transfer to the computer. I prefer using a direct connection for the transfer of files, so that the original filenames and dates are maintained in the transfer. Direct connection is also the quickest method for doing a bulk delete of image files from the iPhone.

How Silent the Trees ■ ProCamera, Snapseed, Portray, Image Blender, Stackables, AutoPainter II

▲ Importing in Lightroom.

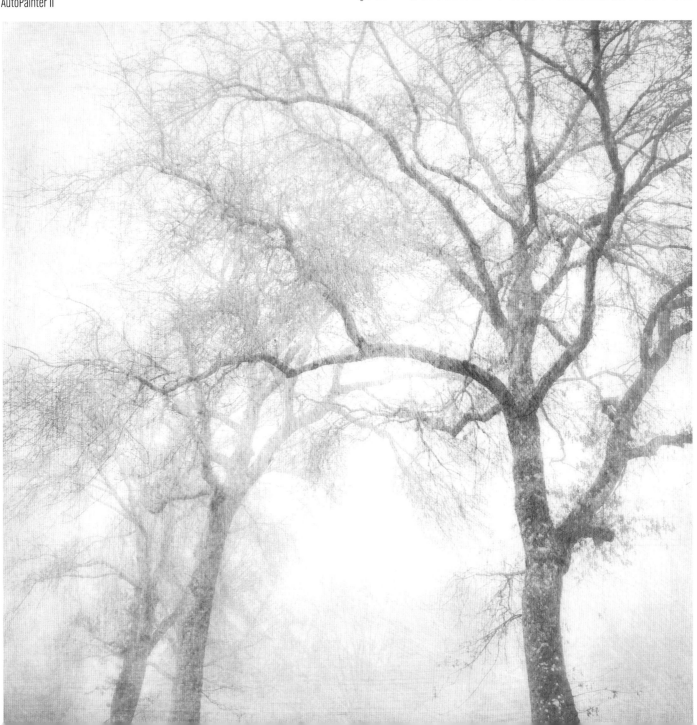

Choosing a Camera App

Flexibility in Camera Apps

The typical digital camera controls are not available with an iPhone camera. The iPhone camera is a simple camera, with a fixed field of view of approximately 35mm and no optical zoom capability. The camera also has a fixed aperture and does not directly provide control of the shutter speed or ISO.

To create the best photographs with an iPhone, you need a camera app that gives you some control. While the native app provided by Apple is easy to use, it does not provide much flexibility. Third-party camera apps have more features to help you get the most out of the iPhone camera. Find a well-designed camera app you like, then use it consistently for taking photos. (Ignore the camera options provided in editing apps; these typically have limited functionality.)

There are several features I consider critical in a camera app. All of these are available in ProCamera, the app I will reference throughout this book. In the App store, look for the app starting with "ProCamera" by Coco-logics. The last part of the app name changes periodically, as the maker revises and adds features to ProCamera.

Independent Focus and Exposure Settings

When you open a camera app and frame a scene, the app typically applies a standard exposure and center focus. You may be able to tap to move the focus and exposure point, but they move together. While this can help with focusing, it can result in a poor exposure (images that are too bright or too dark). Being able to set independent focus and exposure zones within the frame is the biggest key to getting good photographs out of your iPhone camera across a broad range of situations. The sections that follow will show in detail how to use the focus and exposure settings in ProCamera.

Full Resolution Support

Surprisingly, many camera apps don't take advantage of the full resolution of the camera hardware because it results in larger file sizes. Some apps assume users don't want a large file size because their devices have limited space and they will only share the images online or on-screen. If you want the flexibility to print your photographs, you will want to use the highest quality settings, even though it results in larger file sizes.

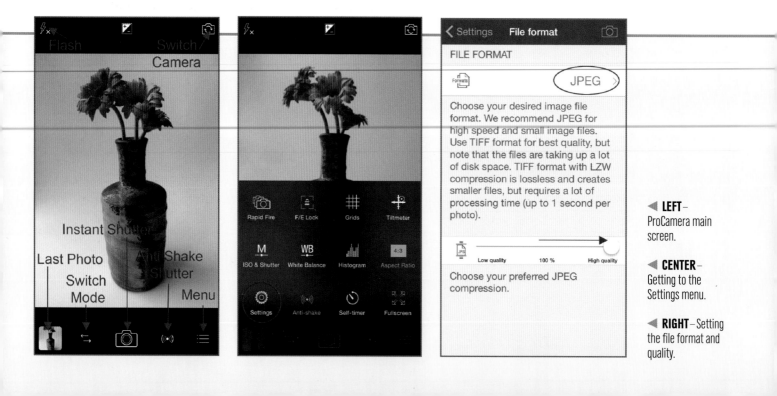

◄ **LEFT** – ProCamera main screen.

◄ **CENTER** – Getting to the Settings menu.

◄ **RIGHT** – Setting the file format and quality.

Night into Day ● ProCamera, Pixlr

In ProCamera, you have to increase the resolution manually. Tap the Menu icon and select Settings. Tap the More option in the top left corner, then select File Format. For most users, I recommend using the JPEG file format and High Quality settings, since these image files will work in all post-processing apps. If you have enough storage space for large image files, you can use the TIFF uncompressed format for best image quality. Not all apps will load TIFF files, however, so you may need to convert the files to JPEG for some editing apps.

Stabilization or Anti-Shake Shutter

The way most people hold the iPhone while taking photographs inherently leads to less stability than when looking through the viewfinder of a traditional camera. This instability leads to blurry photos for the simple reason of the user moving the camera while the photograph is being taken. A stabilization or anti-shake shutter feature prevents the shutter from releasing until the device is stable enough that user movement won't cause blur.

Aspect Ratio Selection

The effectiveness of an image's composition is greatly affected by the final frame. Being able to change the aspect ratio of the frame from a square (1:1) to a rectangle (3:2, 4:3, etc.), is a powerful composition tool available to photographers using iPhones. Being able to see and respond to the effect of different aspect-ratio frames can greatly improve your ability to compose a strong image.

Setting Focus and Exposure Independently

If you struggle with getting good photographs out of your iPhone camera due to incorrect exposure or missed focus, then independently setting the focus and exposure will yield a huge improvement in your photographs. Typically, when you open a camera app, the focus point is set to the middle of the frame and the exposure (the overall brightness/darkness) is based on the brightness in the entire frame. These settings work in situations where you have an evenly lit scene and your subject is in the center of the frame, but this is a rare situation.

To Set Focus and Exposure Independently in ProCamera

First, tap the screen within the frame, but away from the center. Start by tapping where you want to set the exposure. A blue square with a yellow circle within it will appear where you tapped. These are the focus and exposure targets. They will blink for a moment as the camera app adjusts the focus and exposure and then become solid, indicating that the focus and exposure have been set. The image will shift lighter or darker, depending on the area you've targeted.

Next, drag the focus target (blue square) to the location where you want to have the app set the focus. The exposure target (yellow circle) will stay where you first tapped. When you move the focus target to a new location, it will blink again as the focus is reset.

Finally, when the image looks correct to you, tap the Shutter icon to take the photograph. The focus and exposure targets will stay in the same place within the frame for the next shot, unless you move them again or close the app. To reset the focus and exposure back to the default settings while the app is open, tap in the center of the frame.

Setting the Exposure Target

When you move the exposure target, you are telling the app that this location is the mid-range of the brightness for the scene, and the app will shift the overall exposure accordingly. If any areas in the image appear too bright or you want to darken the scene, move the exposure target to a brighter area of the screen. If the photograph appears too dark or you want to brighten the scene, move the exposure target to a darker area of the image.

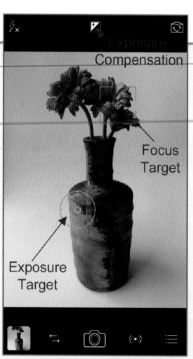

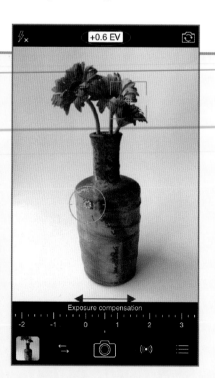

◀ **LEFT**–Tap once to get Focus and Exposure targets.

◀ **CENTER**–Drag targets to set Focus and Exposure independently.

◀ **RIGHT**–Adjusting with Exposure Compensation.

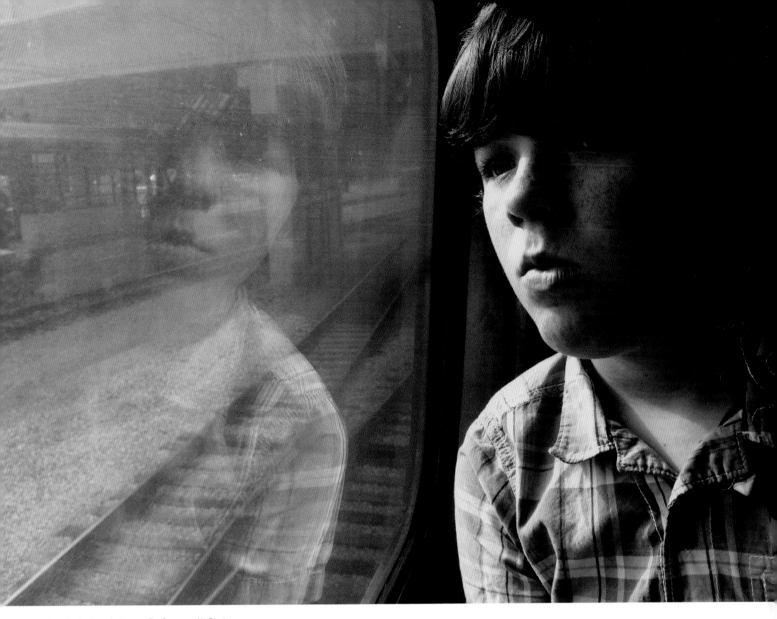

Boy in Contemplation ● ProCamera, Alt Photo

To remember where to move the target, here is a mnemonic: If it's too bright, target bright; if it's too dark, target dark.

Exposure Compensation

As you move the exposure target, you will see a real-time preview of the adjustment to the image. If it's not quite right, move the target to another area or fine-tune your result using exposure compensation. To do this, tap the Exposure Compensation icon at the top of the screen and then slide your finger left or right along the dial. Once opened, the exposure compensation dial will remain open at the last chosen setting. To reset to zero and close the window, double-tap the setting dial.

Lean Toward Underexposure

Always tend toward underexposure. There is more information in the shadows that can be retrieved in post-processing, while information in overexposed, white areas is lost.

Getting Sharp Focus

Focus Is Tricky on iPhones

Anything can look sharp on the iPhone's small screen, but viewing on a larger screen often reveals poor focus. A lot of things can be repaired in post-processing, but focus isn't one of them. It is important to get the focus right from the start. Here are a few ways you can improve your ability to get sharp focus on your iPhone.

Set Your Focus Point

Set the focus point on your intended subject. The iPhone camera does not have an infinite depth of field, which becomes obvious when there's a large distance between the subject and background. Don't assume that leaving the focus in the center will be adequate.

Take Multiple Images

Setting the focus point is not precise. Movement of the camera, subject, or focus target can result in slightly different focus. Once you have the focus set where you think it looks good, take several images. When you review them later, you may see subtle differences in the focus and you can pick the best one.

Use Focus/Exposure (F/E) Lock

If you are having trouble getting the focus to hold on a specific point, you can lock the focus (and exposure) using the F/E Lock mode in ProCamera. This is useful if you are targeting focus on small or close subjects, or if you want an overall blur to your photo. With the F/E Lock off, the focus/exposure are reset when the iPhone moves. With F/E Lock on, the focus/exposure are set manually and held—even if the device moves.

To set the F/E Lock, fill the frame with an object at a similar distance as where you want to focus. To focus close up, you can use your hand as a focus point. Set the focus/exposure targets at the appropriate locations. Once set, you will notice the targets have a lock symbol on them. That indicates they will not change their settings until you manually move them on the screen.

Now, remove your hand and reframe the image as you like, moving the camera so your subject is in focus. Notice that the focus and exposure targets remain locked at their prior settings. You can move the exposure target as needed to reset exposure correctly, while the focus remains fixed.

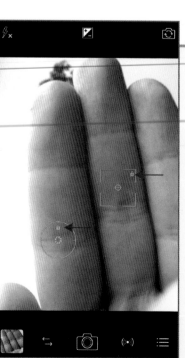

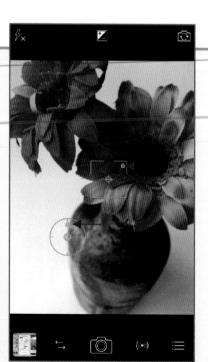

◀ **LEFT**–Turn on F/E Lock.

◀ **CENTER**–Locking focus up close.

◀ **RIGHT**–Focus remains locked.

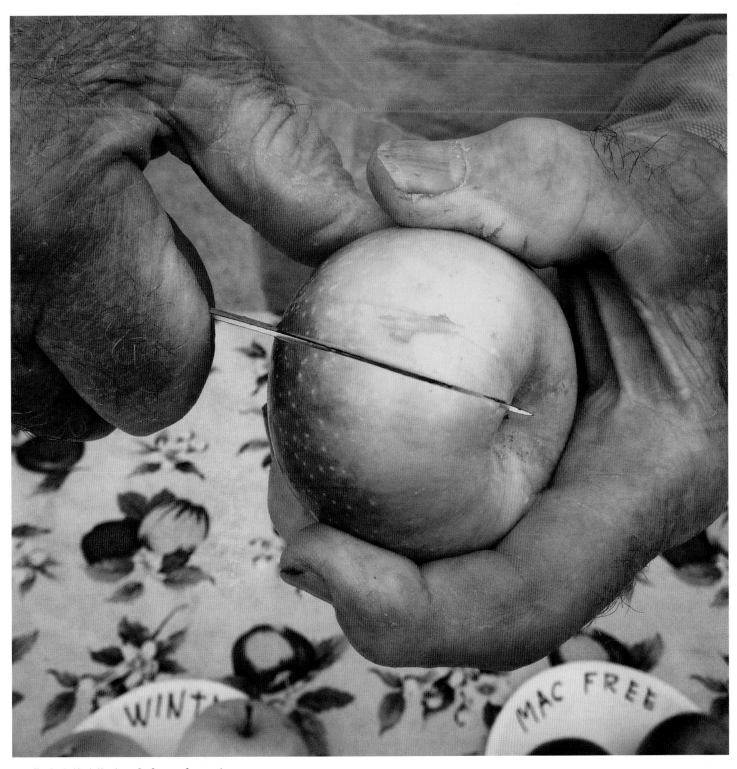

The Apple Man's Hands ● ProCamera, Snapseed

Improving Stability

The maneuverability of the iPhone is both a benefit and a challenge for photography. As you hold the iPhone out at the end of your arms to frame and take a photograph, any small movement of your arms or hands means the camera moves, too. Movement as the photograph is being captured can lead to blurry, slightly out of focus images. Many photographs are ruined because of camera movement by the user, which has nothing to do with the capability of the camera itself.

Let's look at how to improve your stability, which will in turn improve your images. I have found I rarely have issues with camera shake using these techniques.

Anti-Shake Shutter

Unless you are photographing a moving subject or scene where timing is of the essence, use the Anti-Shake Shutter setting available in ProCamera. When you use this shutter, the photograph is not taken until the device is stable enough to avoid camera shake. If you are moving too much after you press this shutter, you will see the Instability icon in the frame. The icon indicates your improving stability by reducing the bars, until the device is stable enough for the shutter to be released.

Use a Light Touch

Even with the Anti-Shake Shutter, you can improve your stability by using a light touch as you tap the screen. It is not necessary to jab the screen forcefully to set focus, exposure, or tap the shutter. You can reduce the movement induced due to tapping the shutter by holding your finger on the Shutter icon, lifting it only when you are stable and ready for the shutter to release. Some photographers like to use the volume (+/−) buttons on the side of the iPhone as the shutter button, but I find I am less stable when I use these.

Firmly Hold and Tuck

Anything you can do to reduce the movement of your arms and hands will increase your stability. Hold your iPhone securely in your non-dominant hand, resting in your palm with fingers wrapped around the back of the device. Tuck your elbows in along the sides of your body, so that only your forearms are held out. Use your dominant hand to set the focus and exposure, then hold the camera firmly to increase stability as you take the image using the Anti-Shake Shutter.

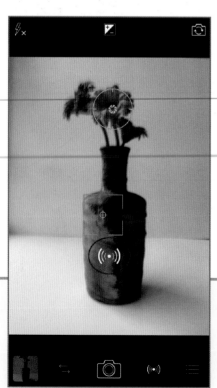

◀ **LEFT** – Instability icon.

◀ **RIGHT** – A firm and stable hold.

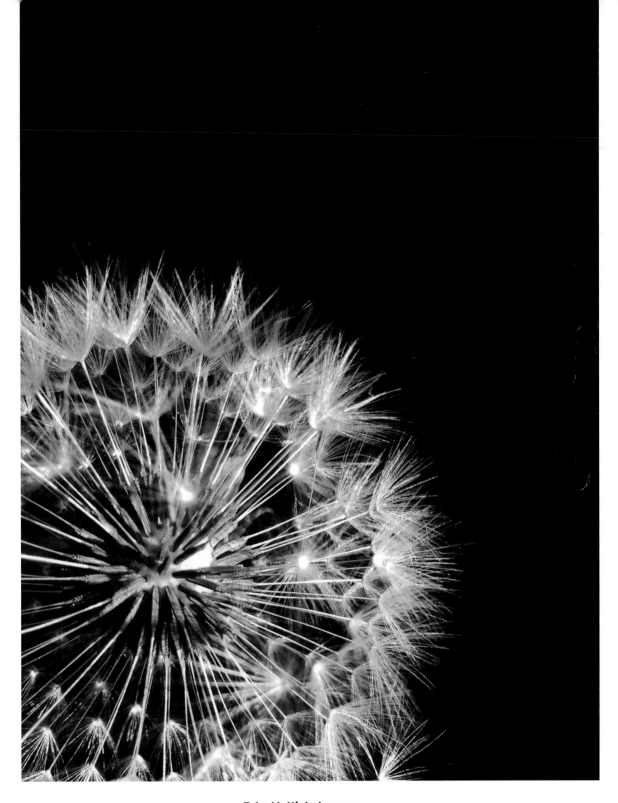

Dandelion ●
ProCamera, Snapseed,
Handy Photo, Big Photo,
Distressed FX

Rest on Something

Resting your elbows, or the iPhone itself, on a fixed surface—a railing, the ground, or your knees if you are sitting—can increase the stability of the camera. Small, portable tripods are also available for the iPhone.

Take Multiple Images

Again, taking multiple images of the same scene will increase your chances of getting a sharp image. As you improve your stability through use of the Anti-Shake Shutter and holding the camera properly, you will find you need to take fewer images to get a good one.

Capturing Moving Subjects

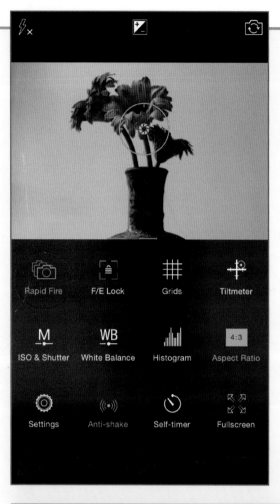

◀ The screen where the Rapid Fire Mode is set.

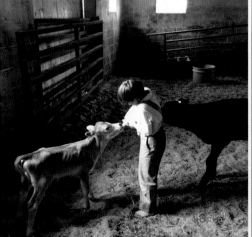

▲ The number indicates the photographs left to process and save.

The previous methods for focus, exposure, and stability work great with static subjects. If you are photographing subjects that move, like children or animals, the Rapid Fire mode in ProCamera is great tool to overcome the shutter lag you experience with an iPhone camera.

When Rapid Fire mode is set, you can press and hold the shutter and the app will continuously take photographs and buffer them for processing. A small red icon appears above the Last Photo window showing how many images are left to process and save. This allows you to quickly take many photographs of a moving subject, so you don't miss out on the action.

Set the Focus and Exposure

If you have enough time, set the focus and exposure in the normal manner for your desired composition. This will give you the best overall results. If you can, anticipate the action and begin taking photographs before the moving object is in the perfect position.

Use JPEG Format

Rapid Fire is only available for the JPEG file format, so if you are using the TIFF setting you will need to change back to JPEG. Depending on the situation, the time you need to change the settings could prevent you from capturing the action.

▼ The final image (facing page) looks calm and peaceful, but the situation was dynamic as can be seen in the series below.

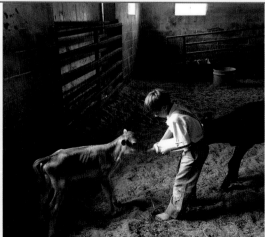
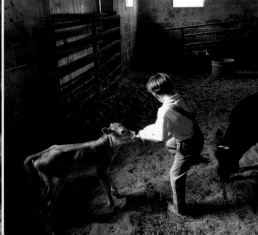

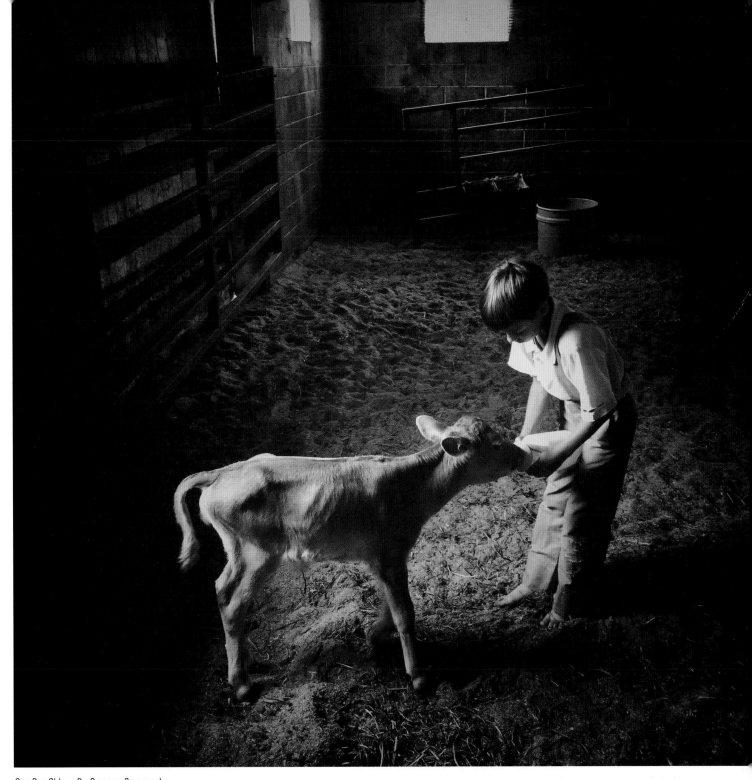

One Day Old ● ProCamera, Snapseed

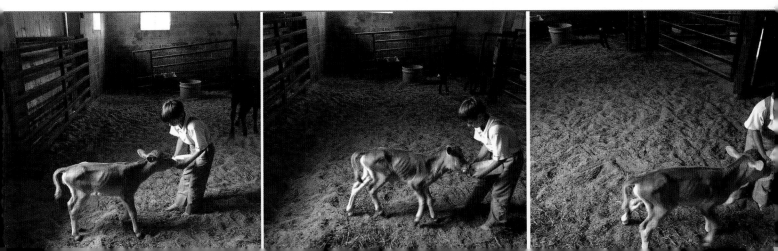

Have you ever been out in bright sunlight and started to take a photo, only to discover you can't see your screen because of all the reflected light? It's a common complaint of new mobile photographers, and something that you can learn to work around. The following are some useful tips.

Shade the Screen With Your Hand

While you are setting up your photograph, use one hand to shade the screen while the other holds the camera. Once you have a composition you like, hold yourself still and remove your shading hand to set the focus and exposure, then tap the shutter.

Move Your Head

Depending on the lighting conditions, the normal straight-on view may not be best. A slight change in your angle of view relative to the iPhone's screen may reduce the reflections you see.

Overexpose to Compose

High contrast images are easier to see on the screen in bright conditions. Intentionally overexposing the image to see high-contrast elements through the reflections may help. Once the image is composed as you like, hold the phone in place and reset exposure before you tap the shutter.

Guess and Check

You probably have a good idea of how you want to compose the image, even if you can't see the detail to frame it perfectly. Frame as best you can, set the focus

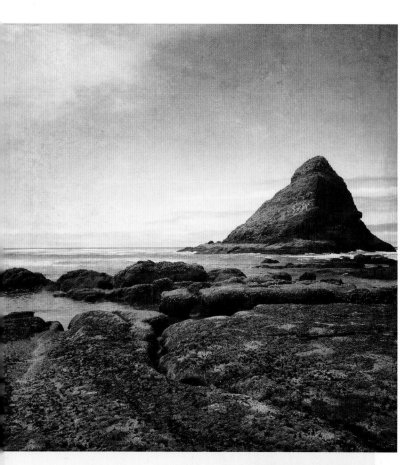

◀ **TOP** – *Low Tide* ● ProCamera, Stackables

◀ **BOTTOM** – *Fog at Sunrise* ● ProCamera, Snapseed, Distressed FX, Stackables, Image Blender

Growing Together ● ProCamera, Snapseed, AutoPainter, Repix, XnView Photo FX, Mextures

and exposure, and take the photograph. Then move into shade to view the resulting image. Turning your body or using your hand to shade the screen are quick ways to reduce the reflections enough to review the image. If the image didn't turn out right, note what you need to do differently and try again.

Take Multiple Images

Once you believe you have your composition and settings dialed in, take multiple images, slightly moving your frame and adjusting the exposure with each. When you cannot see well enough in the bright sunlight to perfect your composition and exposure, it's a good idea to give yourself multiple images to select from later.

Dealing with Lens Flare

Like it or not, the iPhone's wide angle lens is prone to lens flare when photographing toward a bright light source. Sometimes, the lens flare works to the advantage of the image; sometimes it's a distraction. There are few ways you can use, reduce, or eliminate lens flare.

Shift the Light Source

For me, the least desirable type of lens flare happens when a light source is right on the edge of the frame. This results in a bright blob of light at the edge, sometimes with a pink or purple tinge to it. The flare often extends into the frame, affecting the exposure of the area around it, and cannot easily be corrected in post-processing. Shifting the camera slightly, so that the light source is outside of the frame, can eliminate this type of lens flare.

Use a Hand Shade

Even when the light source is outside of the frame, it can still create a bright haze within the frame. Depending on the intended image, the light can create a dreamy effect, as shown in the image *Nature Repeats Herself* (top left) or it can look incorrectly exposed. You can reduce the light reaching the sensor by shading the lens with your hand as you take the photograph. Watch the screen carefully; it's easy to end up with your fingers in the frame—and that's much worse than lens flare!

Shift the Light

When the light source is in the frame, shifting your point of view so the light is blocked by something

◀ **TOP**—Sometimes lens flare is a desirous effect—as in *Nature Repeats Herself*, which was created with ProCamera and Snapseed.

◀ **BOTTOM**—This version of the image was shaded with a hand to reduce flare.

Early Riser ● Pro HDR, LensFlare, Snapseed, XnView Photo FX

else, like trees or structures, can reduce or eliminate unwanted flare. If you are seeking rays of light, you can modulate the effect by playing with your point of view and how much of the light source is blocked or exposed.

Add More Flare

If you like the look of flare, you can add or enhance it with an app. In the image *Early Riser* (above), there was some lens flare in my starting image, and I enhanced it by using the LensFlare app.

One of the most exciting things about flexible camera apps like ProCamera is the ability to change your aspect ratio at the time of taking a photograph. Instead of photographing in a single format based on the camera hardware itself, a limitation of most cameras in the past, you can now adjust frame aspect ratio in real time in your camera app. Want to stick with a familiar 35mm format? No problem. Want to try a square? You can do that, too. This flexibility provides a powerful way to explore and understand the relationship between the frame's aspect ratio and the composition.

Differences in Ratios

Aspect ratio is the ratio of the length to the width of the frame. The larger the ratio between the sides, the more strongly rectangular the frame is. An aspect ratio of 1:1 indicates the sides are equal (the frame is a square) while 3:2, the typical dSLR format, indicates a rectangle where one side is 50 percent longer than the other.

Adjusting Aspect Ratio

To change aspect ratio in ProCamera, tap the Menu icon and then tap the Aspect Ratio icon. Each successive tap on the Aspect Ratio icon will change the aspect ratio through a menu of options. Tapping on the Menu icon again or anywhere on the screen will close the menu and allow you to compose a new photograph. ProCamera will hold your last aspect ratio setting until you change it, even if the app is closed and reopened.

Once you've selected an aspect ratio, the frame shown on the iPhone screen is in that format, so you can see and compose as you photograph.

The resulting image file is saved in the chosen aspect ratio, as well. This means you are not using some of the camera's pixels as you change away from the native camera aspect ratio, which is 4:3. At 4:3, the photograph utilizes all of the camera's pixels (3264 x 2448 pixels for iPhones with 8MP cameras or 4032x3024 for 12MP cameras). At a 1:1 aspect ratio, an 8MP camera utilizes 2448 x 2448 pixels. The same reduction would happen if you cropped a 4:3 image to 1:1 in post-processing, but by changing aspect ratio *in-camera*, you have the benefit of viewing the image in real time and making any desired adjustment to the composition.

◀ Selecting an aspect ratio in the ProCamera app.

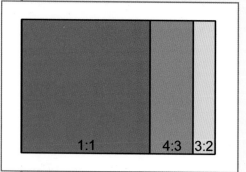

◀ The three commonly used aspect ratios.

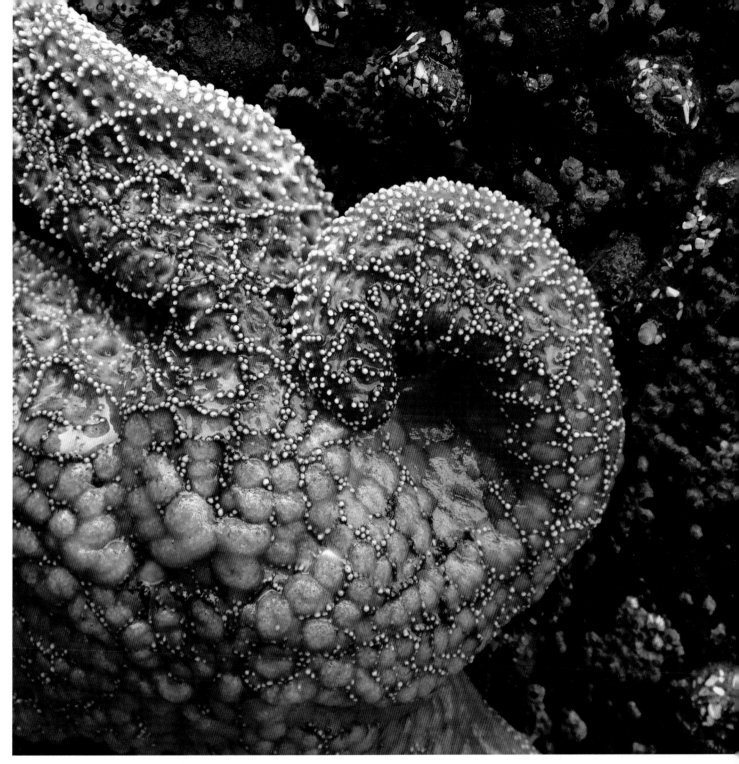

Sea Star ● ProCamera

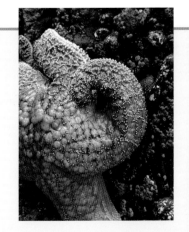

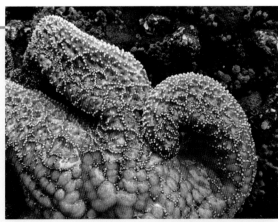

▶ Alternate compositions impacted by the aspect ratios used.

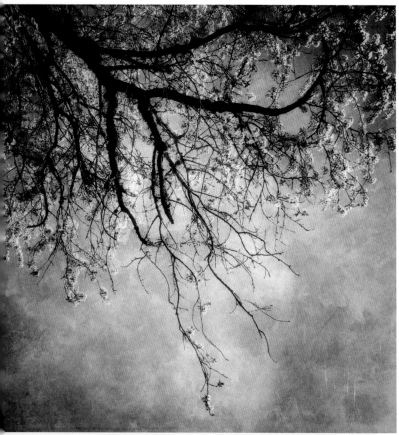

Composition is the arrangement of all of the elements within the frame of a photograph. The elements in a photograph are physical things in the 3-D world, like a bicycle or a cloud, but they also have a graphic impact in the 2-D image as line, shape, and/or color.

A Powerful Tool

Composition in iPhone photographs is not fundamentally different than composition in any other type of photography. What is different is the amount of control you have in your equipment to affect the relationships between the elements. While using a dSLR, you might choose to use a different lens or change the depth of field to aid in clarifying the subject of your composition. With an iPhone, you have fewer tools available to you. However, having fewer choices can actually provide a powerful creative catalyst, engaging and challenging you to create interesting images through framing, point of view, and post-processing.

Basics of Good Composition

The basics of good composition start with answering a simple question: What are you photographing? Before you can compose an image to tell a story, you have to know what story you want to tell. What caught your eye? What made you want to pull your iPhone out of your pocket? Go beyond the obvious—the subject—to study what *about* the subject caught your interest. If you are photographing a bicycle, what is it about the bicycle that you are photographing? Is it the way the light is catching the frame? Is it a contrast of color or shape with its surroundings? Is it the surprise of the bicycle discovered in an unusual place? Answering the

◀ **TOP**– *The Last to Know* ● ProCamera, Handy Photo, Stackables, Autopainter, Repix, XnView Photo FX, Image Blender

◀ **BOTTOM** – *Washburne Beach* ● ProCamera, Stackables

Dreaming of Flight ● ProCamera, Snapseed, Image Blender, XnView Photo FX

question of what exactly you are photographing is the start to creating a composition to tell your story effectively.

Making Choices

Once you know what you are photographing, you have choices to make. What stays in or out of the frame? What aspect ratio do you use? What point of view do you choose? How do you balance the elements available to you? Without the technical camera controls of shut-

ter speed, aperture, or zoom, photographing with an iPhone distills composition down to its essence.

Compositional Skills Transfer

The following sections cover the compositional tools available as you photograph with an iPhone—but keep in mind that they apply equally well to *any* type of camera. If you can learn to create effective compositions with the simple iPhone camera, your compositional skills using other cameras will improve, too.

Visual Impact and Balance

Once you have decided to photograph something, it can be easy to see only the subject that caught your eye and downplay the compositional impact of the surrounding elements, which also end up in your frame. You might think if something caught your eye, it will catch your viewer's eye too, right? Not necessarily. To create an effective photograph, you balance all of the elements, learning to see your intended subject in relation to everything else within the frame.

Balance in a photograph is not so different from balance in the real world. The 3-D world we inhabit is filled with physical things with volume and mass. In the 2-D world of the photograph, these physical things become graphic elements—lines, colors, and shapes. The relative visual impact of the graphic elements (how strongly the individual elements attract the eye of the viewer) affects the balance of the composition and the intended message.

The visual impact of an element is governed by its size, color, contrast, and complexity relative to the other elements in the frame. For example, an element with a bright, vibrant color will have a higher visual impact, attracting the attention of the viewer—especially if seen in contrast with darker or subdued colors.

Symmetry and Asymmetry

Balance can be symmetric or asymmetric. To achieve symmetric balance within the frame, the image is composed with elements of similar visual impact at the left/right or top/bottom. Images with symmetric balance tend toward static and calming. The

Higher Visual Impact	Lower Visual Impact
Bright or warm colors	Dark or cool colors
Brightly illuminated	Shadowed
High contrast	Low contrast
In focus	Out of focus
Edge of frame	Center of frame
Isolated object	Dense, cluttered objects
Break in pattern	Pattern itself
Complexity	Blank space
Human faces	Inanimate objects
Words, numbers	

▲ Relative visual impact comparisons.

Fade to Blue ■ ProCamera, Stackables

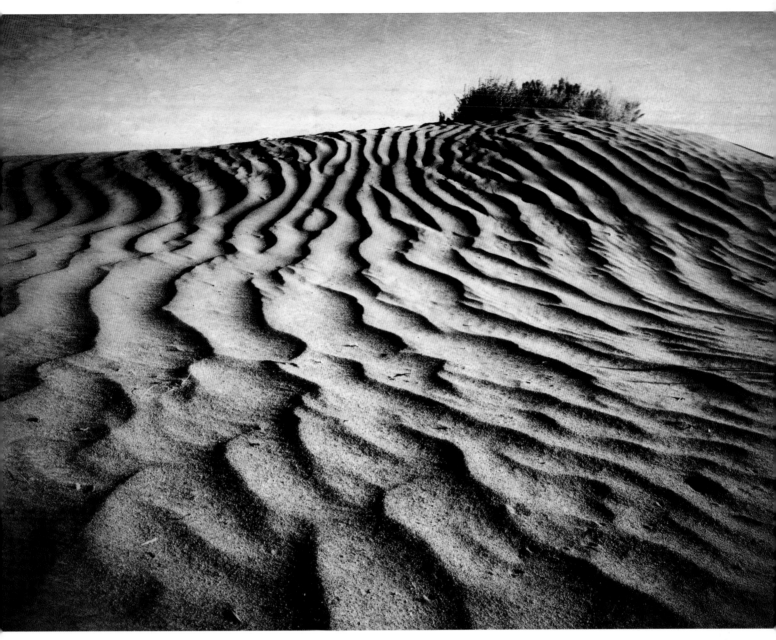

Christmas Valley Sand Dune ● ProCamera, Snapseed, Distressed FX, Image Blender

elements do not have to be identical to achieve a symmetric balance. In the image *Fade to Blue* there is a left/right symmetry created by the treetops, even though they are not identical.

More typically, balance is asymmetric, where the image is composed with elements of varying visual impact distributed throughout the frame. This type of balance is usually more dynamic and energetic than symmetry. In the image *Christmas Valley Sand Dune,* the dramatic lines of the sand dune, the bush at the top of the hill, and the sky are balanced against each other to create an interesting, dynamic composition.

Balance in Post-Processing

It is important to note that the visual impact of elements in a photograph can be significantly affected during post-processing. Changing the color tones, adjusting contrast, or removing unwanted elements will all affect the relative visual impact, giving you further control of the final balance that is achieved in your composition.

Allowing Space

Since objects in the real world become graphic elements in the photograph, it's also important to consider space as a graphic element with visual impact. In a photograph, space is created by a continuous area that has an absence of distinct objects. Space in a photograph is never entirely void; it is always filled with something—whether color, texture, or pattern. A brick wall, the boards of a fence, or an expanse of concrete can all provide space in a photograph because they are viewed as one element that acts as a continuous backdrop or contrast to other distinct elements.

Direct the Viewer

This contrast between space and the other elements makes it a useful compositional tool. The more space you include in your photograph, the easier it is to point the viewer to what you think is important. If you have a large expanse of space, the eye will naturally go to the subject—the object in contrast—rather than the space. Inclusion of space within the photograph gives both the subject and the eye a place to rest, which can create a peaceful and cohesive composition. It can also provide a distraction, if the visual impact of the space is not balanced well against the other elements.

Compositional Choices

Including space in a photograph is not always possible or desired. Filling the frame with elements

◀ **TOP**–Significant open space is not required for good composition.

◀ **BOTTOM**–Space is continuous but not empty.

Remember ● ProCamera, Snapseed, Distressed FX

does not mean the photograph will be overly complex or cluttered. It is a compositional choice, like any other. On the iPhone, where you don't have the range of control through optics or settings as you do on other cameras, allowing space can be an effective compositional tool.

Point of View

The Impact of Angles

Point of view is one of the most powerful compositional tools in a photographer's toolbox. The angle from which you aim the camera impacts almost everything in the composition—the way the subject is captured relative to the light, the relationship of the individual elements to one another, and the relationship of the subject to the background.

Change the Spatial Relationships

Changing your point of view allows you to change, within the frame of the photograph, the relative position of objects that are fixed in the real world. You can't move a building or the tree planted beside it, but you can move yourself and change the appearance of the relationship between the two static objects within the photograph. Think about how point of view works. From one angle, two objects are side by side; from a different angle, the two objects can be separated. The image sequence below illustrates this effect.

Point of View and Control

Point of view allows you some manner of control. By shifting your point of view, you can create separation or connection between objects—even when you have no ability to move them in real life. You can clear a cluttered background by looking up or down on your subject. You can isolate your subject by moving to the left or right. Many of my tree photographs are taken looking up, creating the impression of an isolated tree or branch. In reality, many of these trees are in crowded and cluttered environments, like a parking lot or forest.

Experimentation

An iPhone is a fantastic tool for experimenting with point of view because it is small and maneuverable. You can photograph from underneath a subject or hold the phone out over an edge to capture a perspective you wouldn't otherwise see. Since most of the photographs taken in the world are from human eye level looking straight at a subject, presenting a scene or subject from a distinctly *different* point of view can surprise and engage the viewer. A more interesting photograph is often available just a few feet higher or lower than eye level—or a step or two away.

▼ The same scene from different points of view.

Line and Frame

The interaction of line and frame has a dramatic impact on the effectiveness of the photograph. The frame itself is the outmost edge of the photograph, where the image ends and something else—a mat or blank space—begins. "Framing an image" is the process of deciding how to place the scene you are capturing within those edges of the photograph. This process starts with choosing the aspect ratio of the frame in your camera app, moves through the other compositional decisions (such as point of view and balance), and ends with a decision about where exactly you will place the edges of the frame at the time you take the photograph.

The Impact of Shifts

For any one scene, from any one point of view, there are an infinite number of ways to frame an image. Changes of aspect ratio or slight shifts of the frame—left, right, up, down—affect what is in or out of the photograph. In turn, this affects the balance of elements and the overall visual impact of the image.

Lines

While all of the elements in a photograph interact with the frame, the lines have the strongest relationship with the edges of the frame. As I frame an image, I always ask myself, "What are the lines doing? Are they helping me to convey what I want to convey?" The relationship of line and frame affects the energy in the photograph. Lines parallel to the edge of the frame are more static, while strong diagonals are dynamic. Lines lead the eye through the frame, so you must consider how the viewer may be led. Are the lines leading to something or away from something? Into the frame or out of it?

Lines in a photograph are not always explicit; they can also be implied. A person looking in a direction or an object moving in a direction within the photograph creates an implied line. Anything repeated, no matter the shape, creates an implied line. Watch for these implicit lines as well as explicit lines, playing with how they interact with the frame of the photograph.

◀ The same subject framed in different ways.

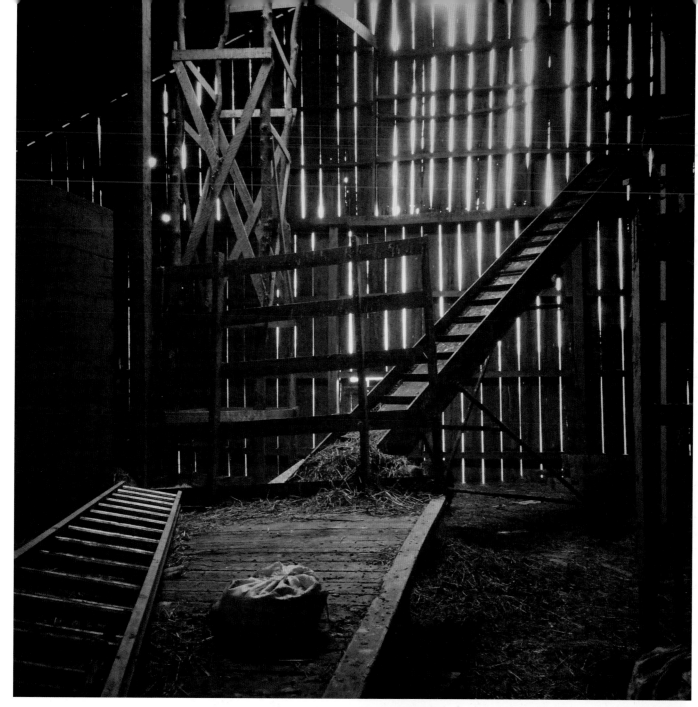

▲ *Hayloft* ● ProCamera, Snapseed

▶ The lines created by shadows lead you to the trees behind.

Experiment

Experiment with line dynamics in your framing by changing aspect ratio, orientation (horizontal or vertical), and tilt. Watch the resulting impact on the composition and the effectiveness of the photograph as you adjust the interaction of line and frame.

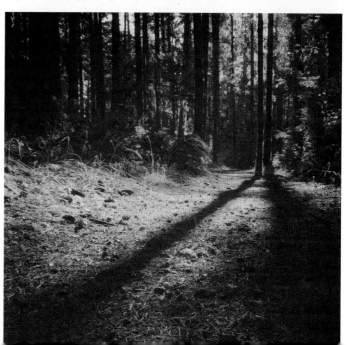

Process of Elimination

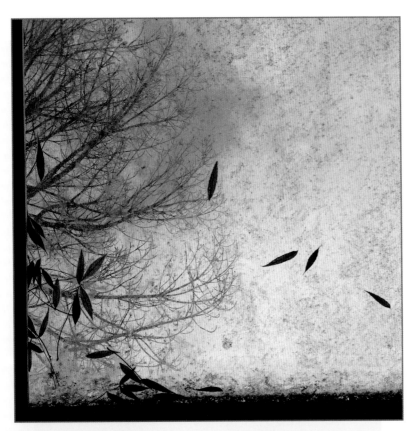

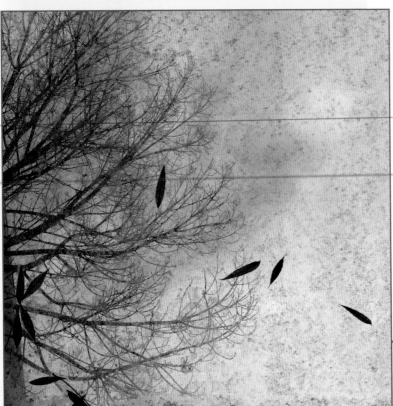

Composition results as much from what you leave out of the frame as what you keep in it. Once you know what you are photographing and what specific aspects you want to capture, you can assess what can be eliminated from the frame. If an element within the frame doesn't help you convey what you intend to convey, it doesn't belong.

Point of View and Framing

Since I am typically photographing out in a real-world environment without control of the relative placement of elements, I use a process of elimination to create compositions. Using the tools of point of view and framing, I eliminate unwanted elements from the final composition. I frame, photograph, and review the resulting image to make an assessment of what elements can be eliminated. Then, I repeat the process.

The Process Described

I will use the photograph *Memory of Autumn* (facing page) as an example to recount my process. First, what was I photographing? Through the roof of a glass bus shelter, I notice both the fallen leaves and the tree they came from. I want to capture this unique connection between the leaves and tree. Next, I photographed the first image (top left), which captures both the bus shelter window frame along with the leaves and tree.

I decided the heavy, dark window frame of the bus shelter was a distraction from the interesting interaction between the leaves and the tree. So, I shifted my point of view slightly and photograph again, composing the image without the bus shelter frame. In reviewing this image, I noticed that I

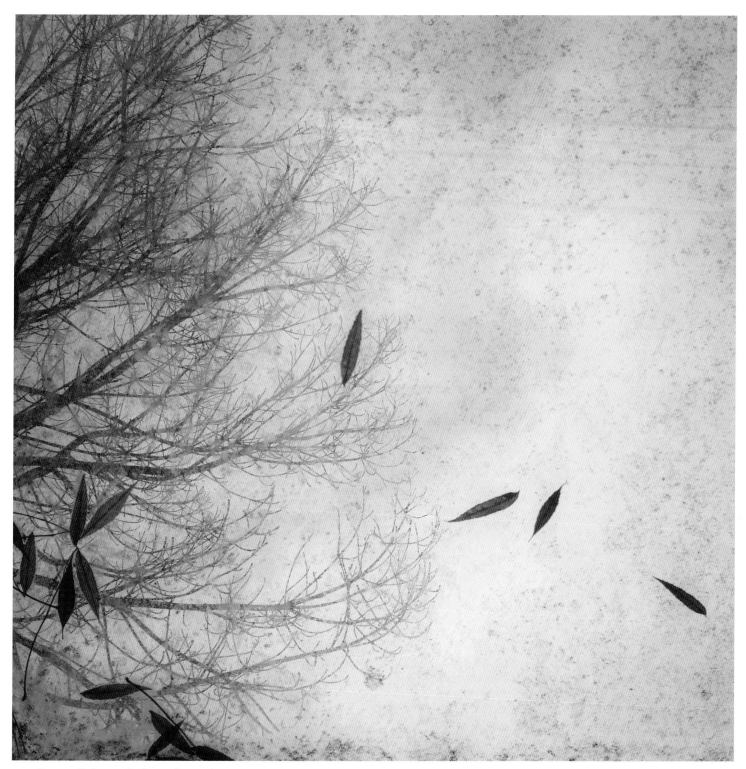

Memory of Autumn ● ProCamera, Snapseed

inadvertently captured a bit of the building behind the tree along the lower left side. When you the shift point of view, it is easy to introduce new distractions.

Finally, I shifted my point of view slightly to frame the scene without any part of the bus shelter or build-ing in the image, narrowing down to include only the elements of leaves and tree. This final image conveys the relationship of the tree and leaves, excluding any distrac-tions. In post-processing, I adjusted the color tones and the image was complete.

Motion Blur

If you want to capture motion blur or practice other long exposure techniques, you will need a dedicated app, since you can't control shutter speed directly on the iPhone. You can get great motion blur and light trails with the iPhone, but the long exposure apps don't work exactly the same as a long shutter speed in a dSLR. Instead of keeping the shutter open for a specified time, the apps take multiple photographs throughout a specified capture duration, blending them together into a final image. The result is slightly different than a long exposure on a dSLR, but just as unpredictable and fun.

My favorite long exposure app is Slow Shutter Cam. This app has focus and exposure targets that are similar to ProCamera, allowing you to tap and set focus and exposure independently prior to taking the photograph. The app takes the capture duration into consideration, providing a brightness in the blended and blurred photograph that is based on your exposure setting.

Capture Modes

There are three modes: Motion Blur, Light Trail, and Low Light. Each mode has a different Blur Strength or Sensitivity setting, and a selectable Shutter Speed (capture duration). In Motion Blur mode, the Blur Strength setting determines how the individual images are combined, resulting in less or more blur for the same capture duration.

Motion Blur Mode

I use this app primarily in Motion Blur mode with intentional camera movement. As with any motion blur or camera movement photography, the results are not predictable. Depending on your chosen scene and desired effect, you will want to play with the Blur Strength and Shutter Speed settings, along with movement of the iPhone camera. For the image *Cattail Dance*, there was left-to-right movement of the cattails from the wind while I was moving the iPhone in an S-shaped up-and-down motion as well. The combination of the two types of movement leads to the impression of a graceful dance. To get this one image I took 57 photographs, playing with different compositions, camera movements, and app settings in each.

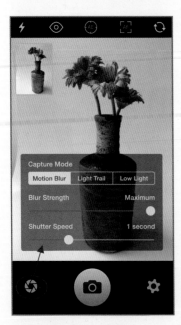
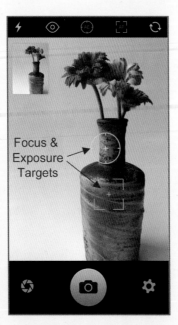

▲ Comparison of minimum and maximum blur strength.

▲ Choosing mode and settings.

▲ Setting focus and exposure prior to capture.

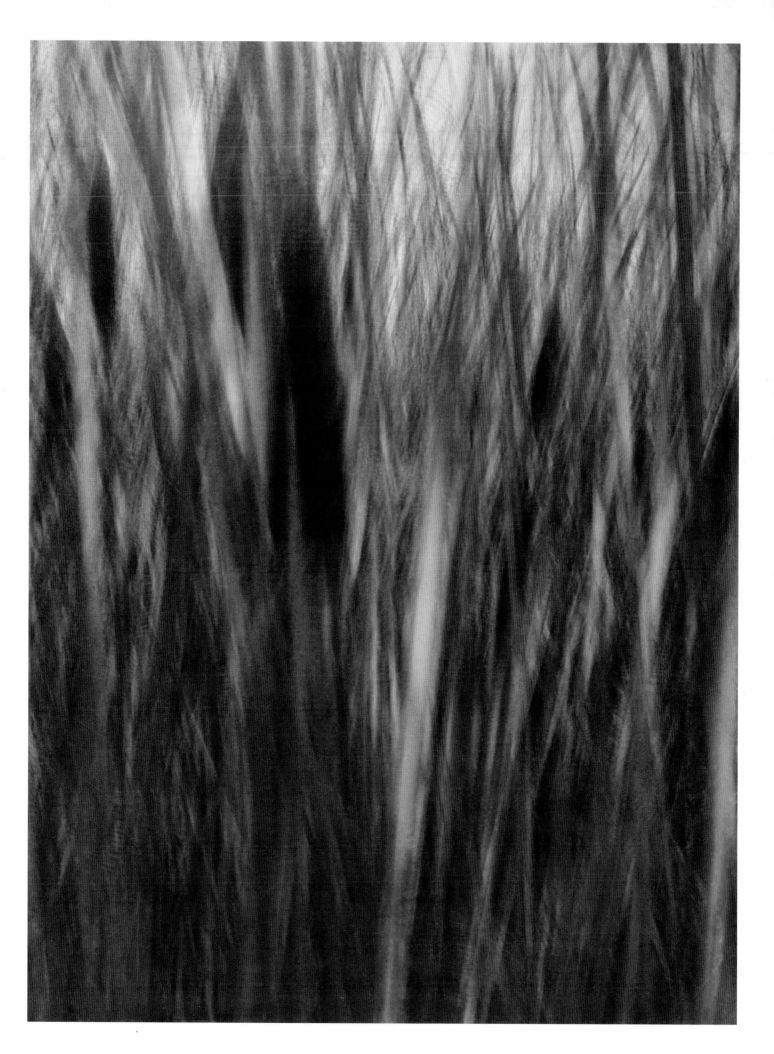

High Dynamic Range

Digital cameras have a limited range of light and dark they can accurately capture, so high-contrast scenes can be a challenge. The iPhone is no exception. If you expose to maintain detail in the brightest highlights, the shadows can be too dark. If you expose for detail in the darkest shadows, the highlights can be overexposed. High Dynamic Range (HDR) apps can help solve this problem. HDR apps blend two images, a light and a dark exposure of the same scene, to create a final image that has detail from the darkest to lightest areas of a scene.

High Dynamic Range Apps

The ProCamera app has an optional built-in HDR mode which is quick and easy to use, but my favorite HDR app is Pro HDR. Pro HDR does a great job of matching the two images, resulting in less blur from camera movement between exposures. It allows you to fine-tune the adjustment of the blended images, all while being a very simple app to operate.

In Auto mode, when you open Pro HDR, you frame your photograph, and then tap the screen to start the process. The app will analyze the scene for a few seconds as it evaluates the range from light to dark, and then takes two photographs at a bright and dark exposure. You don't need to keep perfectly still while Pro HDR is analyzing the scene, but you want to keep still between the first and second exposures.

For a quicker response, use Manual mode. In Manual mode, you move the blue boxes to the highlight and shadow regions of the scene, and then tap the Shutter

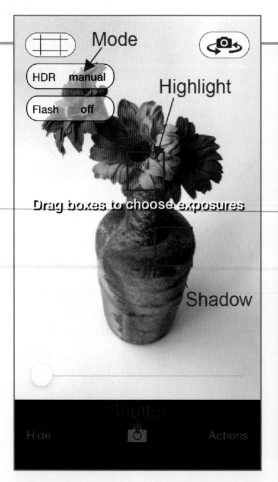

▲ Manual mode.

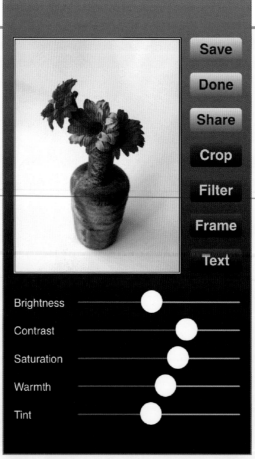

▲ Preview and adjustment window.

▲ Original light and dark exposures.

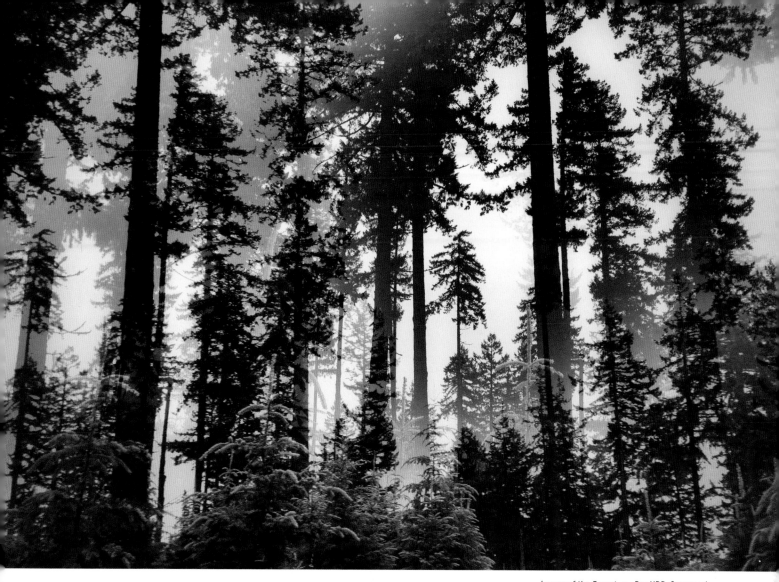

Layers of the Forest ● Pro HDR, Snapseed

button. The app will take two photographs at the exposures specified by the blue boxes.

After taking the two photographs, the app will blend them together and show you the result. On this screen, you can use the adjustment sliders to change the brightness, contrast, saturation, warmth, and tint. Tap Save to add the blended image to the Camera Roll or Done to exit without saving.

To save time, you don't have to adjust the blend settings at the time of capture. Instead, in Settings turn Save Original Images to "on," which saves both the light and dark exposure images to your Camera Roll as they are captured. You can reload the original images into Pro HDR at a later time, adjusting the settings and

saving the result as a new version. You can also load original light/dark exposures saved from other HDR camera apps and use the Pro HDR app to blend them.

Experiment with Double Exposure

I have discovered a fun, non-standard use for Pro HDR as a double-exposure app. If you move and reframe the scene between the first and second image captures, the app will create interesting double-exposure blends. It takes experimentation, because the light and dark areas of the two exposures need to overlap in an interesting way. *Layers of the Forest* (above) was created with Pro HDR using this double-exposure method.

Choosing an Editing App

You've taken a well composed and exposed photograph, so now what? It's time to have some fun with post-processing! You can alter your photographs using editing apps, which allow you to make a range of basic adjustments—from brightness, contrast, and saturation refinements to artistic effects that transform your photograph into something that looks like a painting, a drawing, or some other type of digital art.

Important App Features

There are so many editing apps out there for your iPhone, it can be hard to know where to begin. The next section of the book shares a number of the apps I use as a starting point. As you experiment with editing apps, it's important to realize that not every editing app is created equally. The best editing apps will have the following features.

Full Resolution Output. You want the images you save from an app to have the same resolution as the starting image files you load into the app. It's common for apps to downsize the files they output.

Adjustable Effects. You want an opacity or intensity adjustment available when you apply an effect, to moderate the result.

Progressive Editing. You want to apply multiple effects to the same photograph in the same session within an app, rather than having to save and reload the image.

Undo Last Step. When you apply multiple effects within the same session, you want to be able to undo the last step. It is easier to experiment when you can try different options without worry that you are going to lose a good image by going one step too far in the processing.

There are workarounds I'll share if an editing app doesn't have these features, but editing is simpler if you don't have to take extra steps. Check out the supplemental online material (www.amherstmedia.com/sloma_downloads.html) for information on these features for the apps referenced in this book.

Fetch? ● ProCamera, Stackables

Research

While it's great fun to explore new apps, it can also be frustrating to purchase an app and find out it performs poorly. To find new apps, you can seek recommendations from artists you like—through books like this one, hashtags on social media, or tutorials online. Before purchasing an app, review the images and the description provided by the developer in the App Store. You can often ascertain from the images if an app might fit your style. Before you purchase, you should also read the latest user reviews to make sure the app doesn't have any major functionality problems.

Don't spend too much time on research, though! The amount of time you spend in research should be

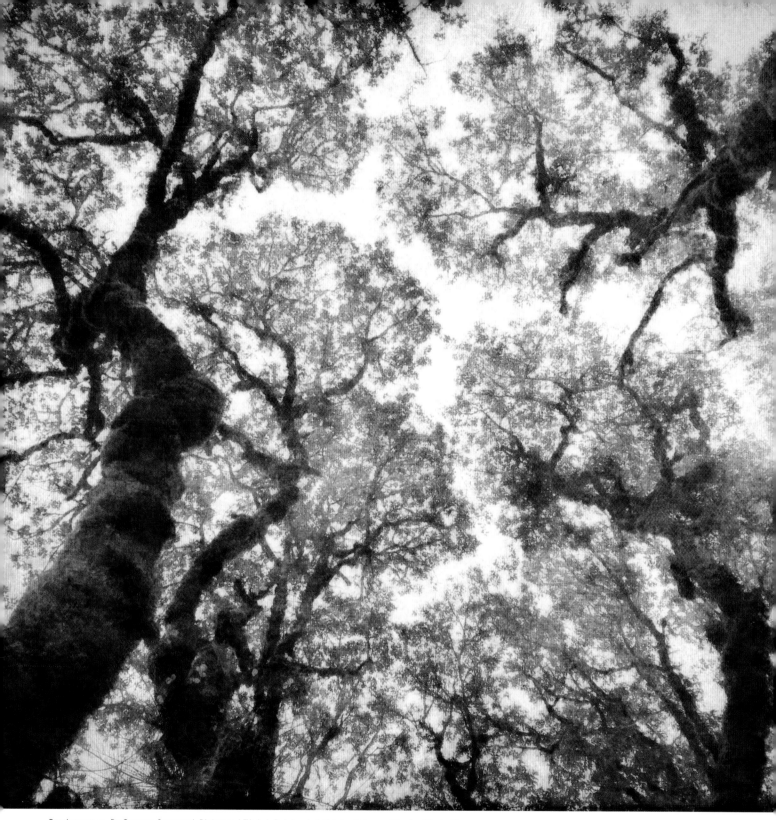

Rendezvous ● ProCamera, Snapseed, Distressed FX, AutoPainter, AutoPainter II, Image Blender, Stackables

commensurate with the cost of the app. Many apps are inexpensive or free, so often it is a better use of your time to download the app and try it out for yourself to decide if you want to use it. Your creative time will be better spent in playing with your photographs, not in researching the perfect new app.

Monitoring the Resolution

There is a sneaky thing that can happen as you edit with apps. While you've made the effort to set your camera app to get the maximum resolution and the best image quality in your captures, post-processing apps often *reduce* the resolution without your knowledge. Some apps have a specified output resolution, while other apps limit your image output resolution based on your device's native camera resolution (for example, 5MP or 8MP).

What to Watch For

To learn how an app affects resolution, there are a couple of things to look for. First, when you save a file, look for an option to choose the file size or resolution. If you don't see an option as you save, go into the app settings and look for an option to set the output file size, quality, or resolution. If there are settings available, always select the highest quality option. If you don't see either of these options within an app, you will need to check the output resolution independently.

Big Photo App

I use the Big Photo app to check and, if necessary, increase the resolution of image files. Open Big Photo and load the image you want to check. Tap the Info icon, and the file information is shown.

If the pixel dimensions are the same as your starting image file, then you know the app you used does not reduce resolution; you can continue processing without resizing.

Boosting Resolution

If the pixel dimensions are less than your starting image file, you have a couple of options to address the loss of resolution. If you plan to blend the image with a higher resolution file in the Image Blender app (covered later in this book), the output of the image blend will conserve the higher resolution of the two files. If you *don't* plan to blend with a higher resolution file, you can increase the resolution using Big Photo's Resize function. Tap Resize and then use the Scale Factor slider to increase the resolution. Be sure the Maintain Aspect Ratio switch is set to "on."

I typically increase the image size to no more than 300 percent of the original file (or 3000–4000 pixel/side). This size range gives me flexibility for printing, without causing obvious artifacts from the resizing in the image file. Some degradation in sharpness or quality can occur with this upsizing process—but since I'm often intentionally degrading the sharpness in my processing, I don't get too concerned about that. If tack-sharp details are important to your work, any upsizing should be kept to a minimum and carefully evaluated on a larger screen.

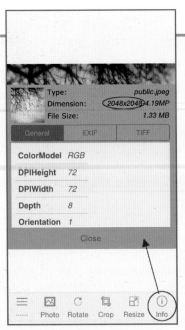

▲ Checking file size and resolution in Big Photo.

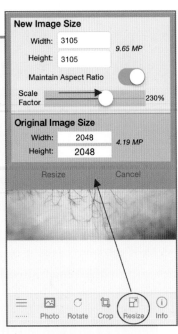

▲ Increasing the image size.

Winterrupted ● ProCamera, Snapseed, Mextures, AutoPainter, Image Blender, Decim8

App Operation

Every editing app available for the iPhone is different in its options and operation. I enjoy this aspect of mobile photography, which involves continually exploring new apps, learning the interface, understanding the strengths of the app, and then combining it with other apps in creative ways. If you don't mind experimenting and deciphering an app on your own, then editing with apps will work great for you. If you are seeking a standard interface or want a specific sequence of steps to achieve a predictable output, then editing with iPhone apps may not be enjoyable for you.

Even though there are no standards of operation, there are some general rules of thumb you can use to help you quickly get oriented within a new app.

▲ Common open file icons.

▲ Common export file icons.

Settings icon Menu icons Slider icon Information icon

▲ Additional common app icons.

Permissions

When a photography app first opens, it will ask for permission to access the Camera Roll. Always answer "yes." If there is a camera within the app, it will also ask for permission to access the camera. Answer "yes" to that too. If you accidentally answer "no," you can change the permissions in your iPhone Settings under Privacy.

Opening or Saving a File

The icons for opening a file or saving a file will often be in one of the four corners of the screen. Look for one of the possible Open File icons or Export File icons.

In most iPhone apps, saving is just one of the possible options for exporting a file from the app. The Export File menu typically allows you to export your image to another app (like Facebook or Instagram), e-mail it, or save the file. Normally, you will want to save the file, so look for one of the terms that indicates you are exporting to the main image file folder on your iPhone, called the Camera Roll, Gallery, Photo Library, or Album. For best results, save your altered images as a new file to the Camera Roll. Some apps provide the option to save non-destructive edits to the original file using a sidecar file, but this feature is not recommended as it is not supported by all apps or computer software you might want to use to open your edited files.

Settings, Info, and Adjustment

If the app allows you to make changes to settings, you will often see a settings or menu icon at the top or bottom of the app interface. For more information on the app, look for the information icon. If you want to know if an app allows you to make adjustments to filters and effects, look for a slider icon.

Adorned and Alone ● ProCamera, Image Blender, Decim8, Aquarella

Zoom and Pan

Many apps allow you to magnify your work (zoom) and move it around on the screen (pan) by using two fingers on the image. Spread your fingers apart to increase magnification, pinch your fingers together to decrease magnification, and drag them together in the same direction to pan.

Don't Be Afraid to Explore

In the following sections, I give a quick overview of some of the useful features of my favorite apps, but this is by no means enough to learn all of the features of these apps. Explore all of the icons and menu options and experiment with them to understand the many features available.

App Organization

As you add apps, it's easy for your camera and photography apps to get lost in the midst of everything else on your iPhone. It's helpful to group your camera and photography apps so that you can find them quickly and easily.

Quick Access Bar

On my iPhone, my favorite camera apps are on the quick access bar along the bottom row, so no matter which page my iPhone opens on, I have the camera apps available. Using Touch ID to unlock the iPhone, the ability to take a photograph in any of these apps is only one tap away.

Editing Apps Folder

I group my editing apps into folders by similar function: cameras, basic editing, filters and textures, painting and

drawing, and geometric effects. I keep my most used apps in a single folder, so it's easy to move between them while I'm editing. This way, I can find the apps quickly without scrolling through multiple pages on the device.

App Order in Folders

The order of apps within the folders is important for quick access, as well. Your frequently used apps should be grouped together on the first page of the folder. If there is an app I want to try to use more in my editing workflow, I also move it to the first page in a folder to make sure I see it.

Group for Efficiency

On my iPad, I use the same folder groupings, but my folders for editing apps (rather than the camera apps)

▲ App organization on the iPhone.

▲ Most used apps are in the first page of a folder.

▲ App organization on the iPad.

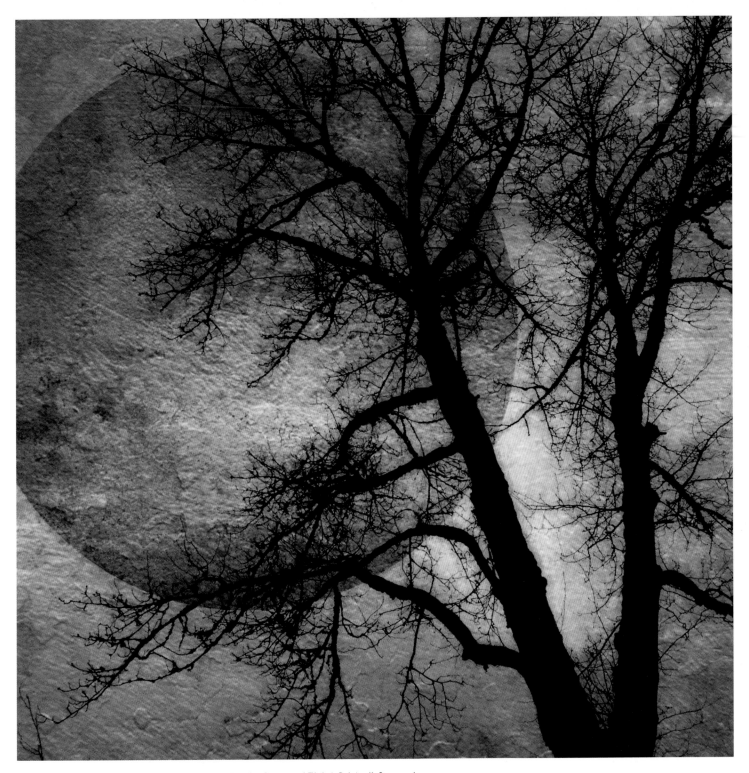

Luminous ● ProCamera, Pixlr, Afterlight, Image Blender, Distressed FX, AutoPainter II, Snapseed

are along the quick access bar on the bottom, since I primarily use this device for editing.

Consider how you use your apps, then find ways to group them together so you can access them efficiently.

There is no correct answer for app organization, and you may need to experiment with different categories before you settle on an organization system that works well for you.

| # Basic Global Adjustments

Almost every editing app with filters and textures also has some functionality to do basic global adjustments on a photograph—things like brightness, contrast, and saturation. My favorite app for most global adjustments is Snapseed, which is free, easy to use, and provides excellent performance. I often start my editing in Snapseed, making basic adjustments to the photograph to prepare it for the next steps in my process.

Snapseed Editing Basics

When you begin Snapseed, tap Open to load an image from the Camera Roll. Once you have selected your photo, you will be on the Home screen. To access the editing options, tap the Menu icon. From the Tools menu, access the global adjustments by tapping the Tune Image option.

Within each Snapseed editing option, you scroll up and down on the image to access a menu of adjustment possibilities. For Tune Image, these are Brightness, Ambiance, Contrast, Saturation, Shadows, Highlights, and Warmth. As you move your finger up or down on the image, you move through the options and they will be highlighted blue in turn. To select a tool, lift your finger when the desired option is highlighted blue.

Once you have selected the option, slide your finger left or right on the image to make the adjustments, increasing (right) or decreasing (left). The information window at the bottom of the screen shows your current selection and how much it has been adjusted, either from 0 to 100 or –100 to +100. The zero reading indicates the starting point of the image when the menu was opened.

Finish and Save

When you are finished with your global adjustments, return to the Home screen by tapping either the Discard icon (to exit without making changes) or the Commit icon (to exit with the changes applied). It is important to note that your changes are not automatically saved when you return to the home screen. You must go to

▲ Snapseed Home screen.

▲ Snapseed Menu screen.

▲ Adjustment options.

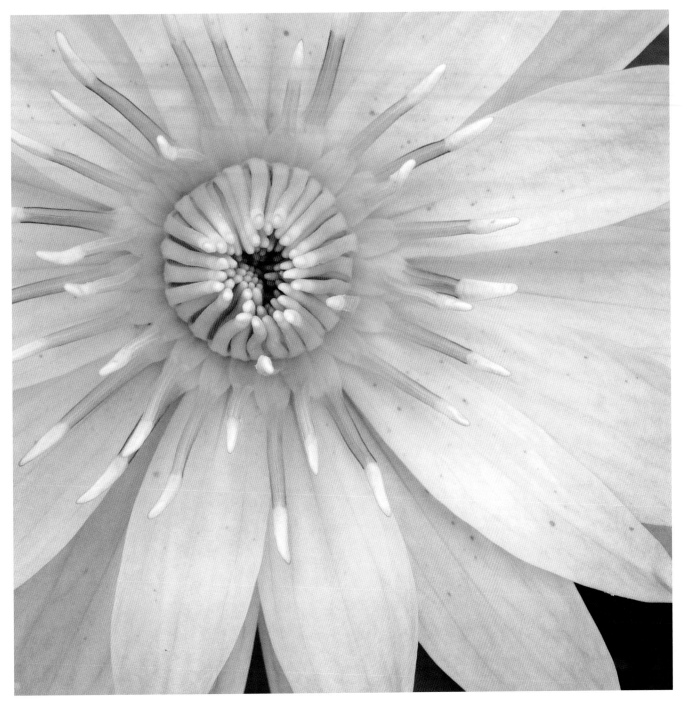

Water Lily ● ProCamera, Snapseed

the Save menu and save your new version to the Camera Roll. Select "Export" to save an altered copy to the camera roll.

Push Settings to Extremes

If you aren't familiar with the basic adjustments Snap-seed provides, you can learn them by pushing each setting to its extremes. Try this on different types of photos. It will help you understand what each tool does to an image and when you might want to use it. If you don't like a result, it's easy to discard your changes and start over.

While global adjustments are quick and easy, there are times when an adjustment targeted to a specific area of the photograph is needed. Snapseed's Selective editing option is unique in allowing you to adjust the brightness, contrast, and saturation in a specific region of your photograph.

Marker and Range Adjustment

From the Tools menu, open the Selective option. Tap the Add Marker icon and then place the marker on the image. The marker will be highlighted blue, indicating it is the active marker for adjustments. If you hold your finger on the marker, you will get a magnifying glass which helps you to precisely select the marker location. Since the spot adjustment will be done only on similar pixels, you want to be specific in your placement.

Once you have placed the marker, you need to select the range of adjustment. Using two fingers, pinch or spread your fingers to select the range. You will see some pixels switch to red; these indicate the pixels that will be affected by this marker.

Adjustments

Moving your finger away from the active marker, swipe up and down on the screen to select the type of adjustment you want to make: brightness, contrast, or saturation. When your option is selected, swipe left or right to make the adjustment. (*Note:* If you swipe on the active marker, you will move the marker.)

You can adjust brightness, contrast, and saturation independently for a marker. You can also add multiple markers if you have more than one spot you want to adjust, following the same procedure. Tap any marker to make it the active marker for adjustments. To see the results of your changes, tap the Compare to Original icon.

Discard or Commit

Once you exit, using either Discard or Commit, your specific adjustment points are lost. When you re-enter the menu for further adjustments, you will need to place new markers and start the process again.

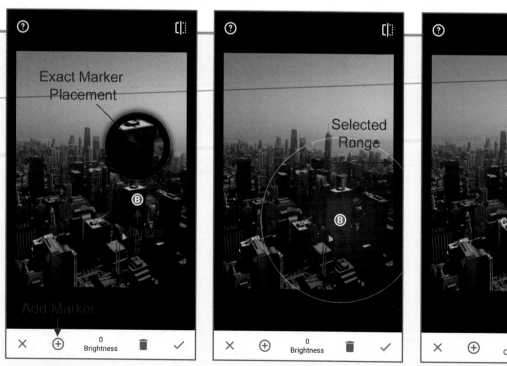
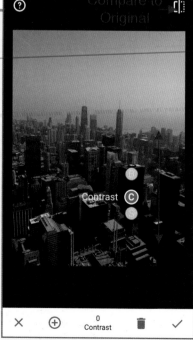

▲ Placing a marker. ▲ Selecting the range. ▲ Selecting adjustment type.

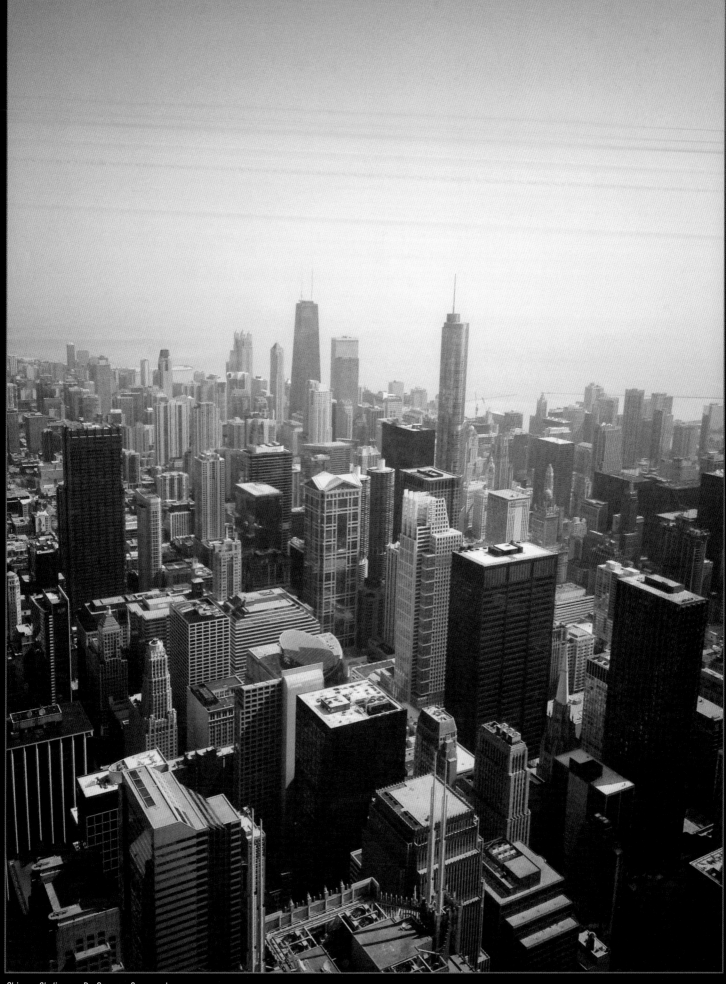

Chicago Skyline ● ProCamera, Snapseed

Even when you've done your best to reduce distractions at the time you are taking your photograph, there are occasions when you just can't eliminate all of them. In some cases, you can remove distractions after the fact by retouching or cloning with an app like Handy Photo.

Removing Distractions

In Handy Photo, open your image using the Gallery icon. Once an image is loaded, you tap the Main Menu icon to access more menu options. You can move through the menu options by dragging and rotating the ring around the Main Menu icon. To select a menu option, tap its icon.

For quick removal of a distraction, try using Handy Photo's retouch function. When you tap the Retouch icon, a new menu appears in the bottom left corner. Select the Brush icon, and then you can paint over the area you want to eliminate. Areas you have painted are highlighted red. If you paint an incorrect area, you can tap the Erase icon to erase portions of the painted area—or you can tap the Undo icon to eliminate the last selection you painted. To paint a detailed selection, you can adjust down to a smaller brush size, as well as zoom in tightly on a small area of the photo by pushing apart with two fingers.

Retouch and Content-Aware Fill

When you have finished painting the area you want to retouch, tap the screen. Handy Photo will then apply a content-aware fill, replacing the pixels inside the painted area with pixels from just around it. If you don't like the result, you can undo the retouch and start again. You can also repeat the process multiple times in different areas of the image.

When you are happy with the result you have achieved, tap the Commit icon in the lower right to apply the changes and return to the main menu. When you are finished with your edits, go to the main menu and save your image to the Gallery.

Since Handy Photo's retouch function uses a content-aware fill, it works best when eliminating distractions that are surrounded by a consistent background. If you are getting extraneous imagery copied into the painted area, reduce the area you are trying to retouch at one time. Start from the most open area, retouch a

▲ Handy Photo Main Menu.

▲ Handy Photo Retouch menu.

▲ Finished retouch.

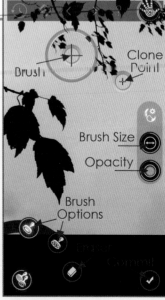

▲ Clone Stamp menu.

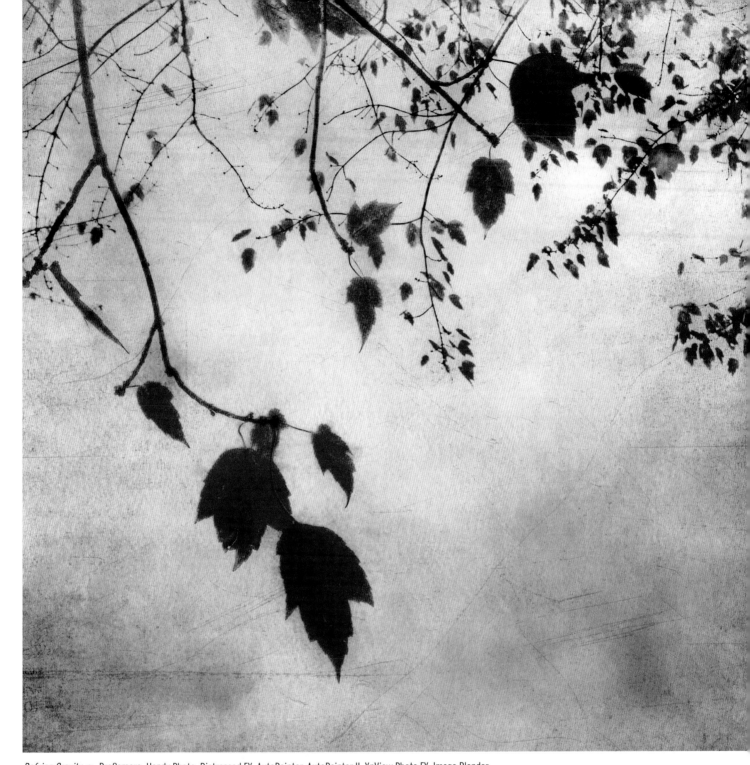

Defying Gravity ● ProCamera, Handy Photo, Distressed FX, AutoPainter, AutoPainter II, XnView Photo FX, Image Blender

small part of the distraction, and then work closer to the more complex parts of the image.

Clone Stamp

If Retouch doesn't work to conceal the problematic image area, you can also use the Clone Stamp function to directly copy pixels from one part of the image over the pixels in another area of the photo.

To do this, tap on the photo to set a clone point (selecting the "good" pixels you want to copy over the "bad" area) and then paint with the brush in the area where you want to replace the pixels.

Paired with the right photographic content, a simple shift in color tones can evoke drama or nostalgia, celebratory joy or poignant sadness. When you adjust the color tones, you adjust the emotional tone of the photograph. Color also begins to determine whether your photograph stays grounded in the real world or begins to move into the realm of abstract dream worlds.

Color filters are the most widely available alteration within iPhone photo editing apps. Some apps provide simple one-touch filters, while others add extensive choices of color tones and options for adjustability. If you want to try a range of filters that approximate traditional photographic processes, apps like VSCO Cam are the standard.

Color Beyond the Expected

For much of my artwork, the starting point is to alter color beyond the expected photographic tones. Mex-

Suggested Apps for Color Filters

Afterlight	Photocopier
Alt Photo	Pixlr
Handy Photo	Snapseed
iColorama	VSCO Cam
Mextures	XnView Photo FX

tures is a great app for making these kinds of dramatic color shifts, with a wide variety of colors and adjustments available.

When you open Mextures, you choose a photo from the Library (Camera Roll) and have the option to crop before you are taken to the main menu. For altering color, use the Radiance menu. Once you are in the Radiance menu, tap a filter to apply it. Within this menu, you can quickly rotate the filter to increase or decrease its opacity. The rotation is an especially nice feature in this app, which allows you to customize the filter application for each photograph.

For further refinement of your filter, you can change the blend mode or make other photographic adjustments. Tap the Blend Mode icon to explore those options. Take time to experiment here. Changing the blend mode alters how the colors are applied to the photograph, giving an even wider range of options for each color filter.

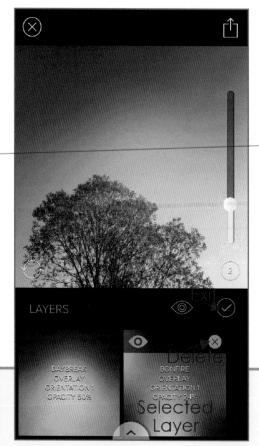

◀ **LEFT** – Radiance Menu.

◀ **RIGHT** – Layer Menu.

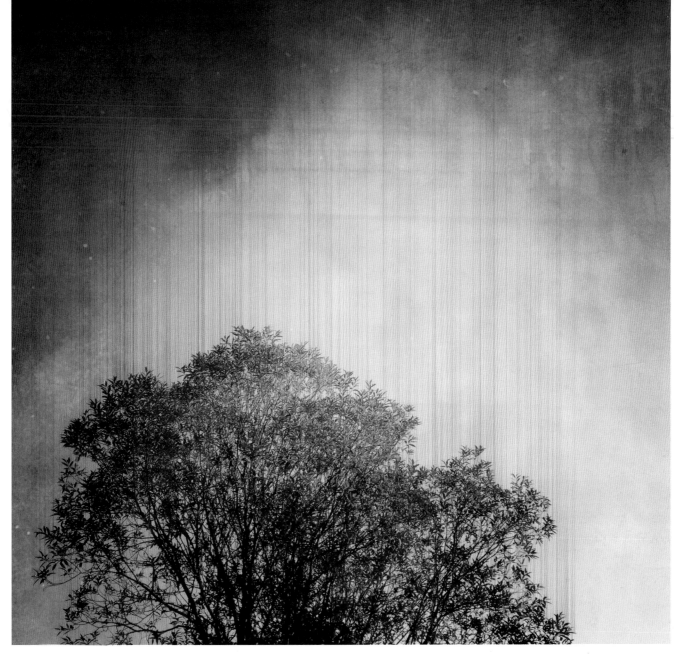

Heat Rises ● ProCamera, Snapseed, Mextures, Decim8, AutoPainter II, Image Blender

Layers and Formulas

Once you like the settings for the current filter, you can add another layer and start again, altering the color further or adding other effects. As you add layers, you can go back and adjust any previous layer. Tap the Layers icon to see the list of layers currently applied. Tap a layer to select it and then tap the Exit icon to edit or tap the Delete Layer icon to delete.

Mextures also has Formulas, complete sets of layers created by other artists to achieve a specific effect using the app. Formulas are a quick and easy way to experiment with possible options for your photograph. If you look closely at the layers and blending modes used in the Formulas you like, you can learn more about using the app on your photographs.

When working with color filters, apply the filters *before* you make basic global adjustments to your photograph. The filters often impact the brightness and contrast along with color, so any global adjustments made prior to the filter application may be wasted effort.

Without the impact of full color to attract or distract the viewer, monochromatic images turn the focus to the lines and tones in the photograph. Since photographic history is rooted in monochromatic images, these filters are widely available in iPhone apps. Apps with monochromatic filters create effects that range from faded sepia to dramatic film noir looks.

Noir Photo

One of my favorite apps for quickly achieving a dramatic black & white photograph is Noir Photo. Once you open an image in Noir Photo, tapping any of the presets both converts the photograph to a toned black & white image and applies a highlighting effect. To move and

Suggested Apps for Monochromatic Filters

Alt Photo	Noir Photo
Dramatic Black &	Snapseed
White	Stackables
iColorama	VSCO Cam

resize the highlight area, tap the image and an ellipse appears. Using one finger, you can adjust the position of the ellipse. With two fingers, you can tilt, increase or decrease the size of the ellipse.

You can also fine-tune the film noir effect by using the Outer Brightness, Inner Brightness, and Contrast

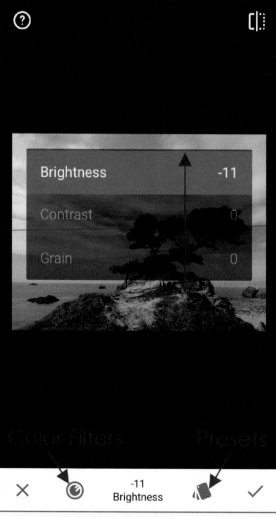

◀ **LEFT** – Noir Photo app.

◀ **RIGHT** – Snapseed Black & White menu.

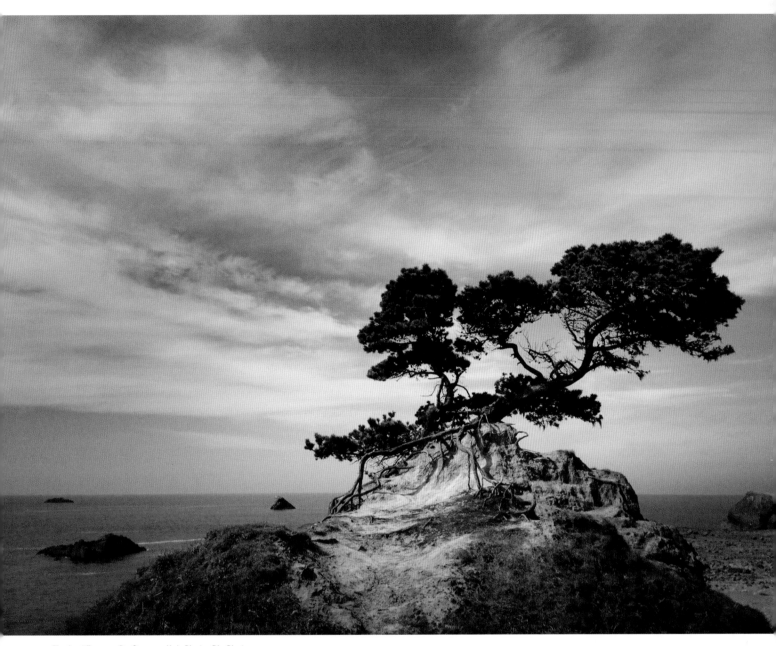

The Last Tree ● ProCamera, Noir Photo, Big Photo

dials along the bottom. Use the Color Tone icons to switch the color of the monochromatic effect between sepia, grey, blue, and green.

Snapseed Black & White

Snapseed also provides a basic black & white conversion with a nice range of adjustability. From the Filters menu, select the Black & White option and begin adjusting your brightness, contrast, or grain. You can also select Color Filter to help separate the tones in the black & white conversion based on the original colors captured in the photograph.

To create a custom look, save your black & white conversion and then apply a color filter, such as Snapseed's Vintage effects. Since the color filters shift the highlight and shadow tones, regardless of whether the starting image is in color or black & white, you end up with a uniquely toned monochromatic image.

A texture is a separate image file, one with only color and texture, that you apply to your photo. Textures can range from subtle grain variations, to canvas weaves, or dramatic crackling paint. Many apps include options for applying textures along with color filters.

Starting with Stackables

One of my favorite apps for adding texture is Stackables, which has a wide range of textures as well as options to control their application. Once you've loaded a photo into Stackables and selected the file type to save as (JPEG, PNG, or TIFF), Stackables starts by adding a texture layer. You can scroll through the texture options on the right side, tapping different textures to see their effects on your image.

Refining the Look

When you find a texture you like, you can make adjustments through rotating the texture, changing the blend mode, and adjusting the opacity. Tap the current blend mode to select options other than the default mode, which is Overlay. Once you've selected a mode, the

Suggested Apps for Textures

Distressed FX Mextures
FX Photo Studio Stackables

opacity slider allows you to control the intensity of the blend. (More on blend modes in later sections.)

Multiple Layers

Much like Mextures, Stackables allows you to add multiple layers with different types of effects. Simply tap the Add Layer icon and a new layer is added. Once you have added a new layer, you can change the layer type, and make new selections and adjustments. Stackables has many layer types beyond textures, including color filters, gradients, patterns, and global adjustments.

Formulas

Stackables also has Formulas, which are great starting points for editing. Tap the Formulas icon and then tap an individual Formula to preview it on your photograph.

◀ **LEFT**–Starting layer.

◀ **CENTER**–Adding a new layer.

◀ **RIGHT**–Finding a Formula.

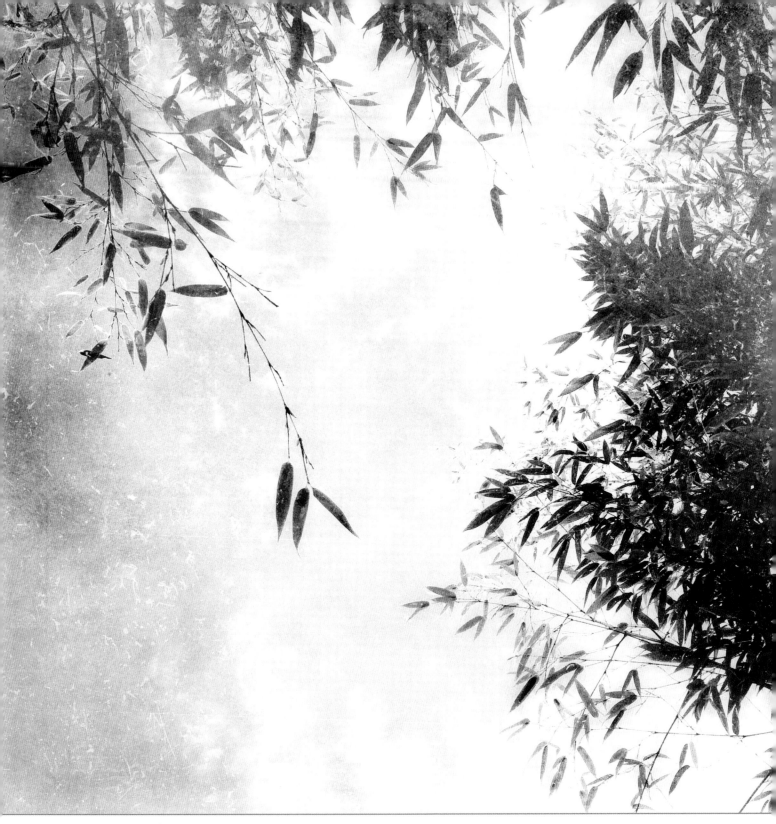

Undeniable ● ProCamera, Stackables

Once you find a Formula you like, tap the Apply icon in the lower right. You can now edit any layer in the Formula, add your own layers, or delete layers to further customize your results. If you create an effect you like, you can save it as your own Formula—so it's quick to reuse in the future.

Grunge effects take the concept of textures to the extreme. These distressed effects introduce dramatic variations (think scratches, water marks, scuffs, folds or other damage) and looks from timeworn vintage to gritty urban. With the right starting photograph, going grungy can be downright fun.

▲ Classic Vintage Photo app.

◀ Grunge-tastic app.

Suggested Apps for Grunge Effects

Classic Vintage Photo	ScratchCam FX
Grungetastic	Snapseed
Pic Grunger	Vintage Scene

Classic Vintage Photo App

Classic Vintage Photo is a wonderful app for adding grunge effects. After you load a photo, you can select options in four categories: Paper, Crackle, Border, and Sepia. Select a category by tapping on it, then scroll through the effect options on the right side. Tap an option to apply the effect to your image. You can adjust the intensity of the chosen effect by adjusting the opacity in 25 percent increments.

I often start my edit in this app by setting the opacity for all categories except Paper to 0 percent. Once I choose a Paper effect I like, I experiment with other effects by turning on Crackle, Border, and Sepia one by one.

Grungetastic App

Grungetastic is an app that creates similar effects but with a greater range of adjustability. You can choose between several categories, such as Pop Grunge, Bleached, and so on. Within each of these categories, you can select a preset effect to get close to a look you like, then fine-tune the look with the Adjustment menu.

Grungetastic has a random selection option, a great feature for quick experimentation. Tap the Randomize icon to rapidly cycle through alternate effects. (*Tip:* Keep your eye out for randomize options in the apps you use. These can help you quickly find new combinations and discover possibilities that look great with your photograph.)

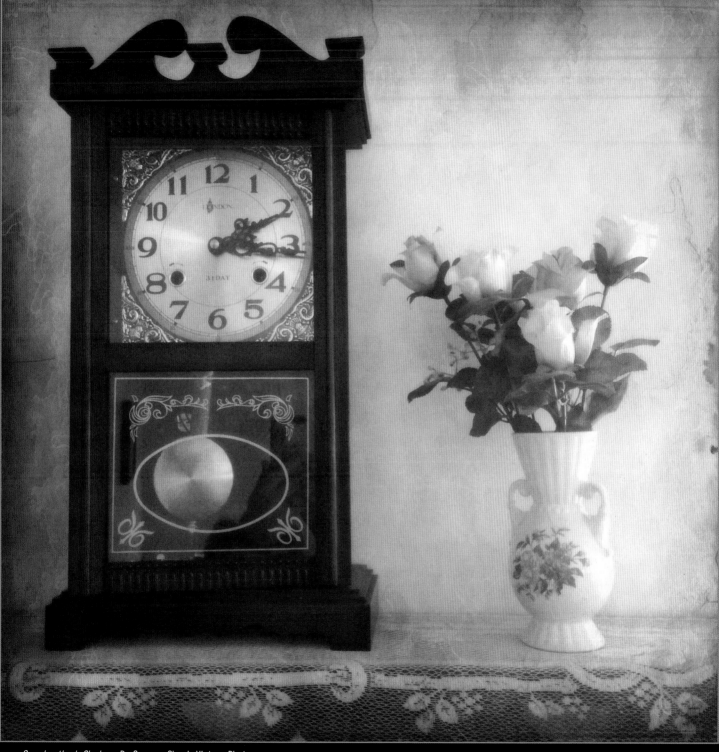

Grandmother's Clock ● ProCamera, Classic Vintage Photo

With all of these amazing editing apps at your fingertips, a photograph no longer has to remain looking photographic. You can completely transform a photograph by using artistic effects, like painting. I use painterly effects when I'm trying to soften the edges of an image, add variations in color and texture, or take the image a step away from realism. From oil to acrylic to watercolor, there are apps that approximate most painting mediums.

Glaze App

Glaze is an app that applies painterly effects, most of which give the impression of oil or acrylic painting. You apply an effect to your chosen photo by scrolling along the bottom and tapping an option. The app will take a few moments to apply the effect. You can try other effects, switching back and forth between your last few selected options to compare results quickly.

Suggested Apps for Painterly Effects

Aquarella	PhotoArtista—Haiku
Artista Impresso	PhotoArtista—Oil
AutoPainter	Popsicolor
AutoPainter 3	Repix
Brushstroke	Waterlogue
Glaze	

One of my favorite things about Glaze is that you can save an image at a higher resolution than the original photograph. I always save with the largest output resolution, which is 4096 pixels on the long side. When you choose the largest resolution, you may get a warning message from Glaze that it might crash if there is not enough available memory. Go ahead and tap Continue; it usually saves without issue. If it does crash, close all other open apps, open Glaze, repeat your edit and save again.

Waterlogue App

For watercolor effects, Waterlogue is a quick and easy app to use. When you open the app and load a photo, the app automatically applies the Natural effect. To change the effect, scroll along the bottom and tap an alternate option. A small window over your image will pop up with a preview. If you like how it looks, tap the preview window to apply the new effect.

For adjustments before saving, continue to scroll over to

◄ **LEFT** – Glaze main menu.

◄ **RIGHT** – Selecting effects in Waterlogue.

Lily Pond ● ProCamera, Handy Photo, XnView Photo FX, Decim8, Glaze, AutoPainter II, Repix, Image Blender

the right in the menu. You can change the size of the output (I always select Giant), the intensity (lightness/darkness), and whether you have a white border or not.

Unlike Glaze, Waterlogue (like many other apps) does not create files at your full image resolution—even if you

select the highest resolution option. Be sure to check the output resolution when using these types of apps, or check the supplemental online material (www.amherstmedia.com/sloma_downloads.html) for the output resolution information on all apps referenced in this book.

For a looser look, try chalk and pencil effects. These types of effects can approximate a sketch from your photograph. I love the variation that a pencil or chalk texture adds to lines and forms within an image.

AutoPainter II App

One of my favorite effects of this type is the Chalk effect in the AutoPainter II app. This effect provides great texture as well as enhancing the contrast between the light and dark tones in the image.

AutoPainter II also has an easy to use interface. Load an image, tap the Selected Effect box if you want to change the effect, and then tap Start. The app then runs through three processing steps: Underpainting, Dry Reveal, and Detail Brush. You can stop the app at any point during the processing by tapping the Cancel button at the bottom, which provides an even wider variety of outcomes.

Suggested Apps for Chalk and Pencil Effects

AutoPainter II SketchMee

PhotoArtista—Sketch XnSketch

Portray FX Photo Studio

Repix

Stopping the app after the Dry Reveal step can create a great background with color and texture depth for blending back with the original image (more on that later). There are several apps in the AutoPainter series, and they all work in a similar way.

Portray App

For more varied pencil effects, my go-to app is Portray, which also includes many other artistic and painterly effects beyond pencil. Portray is unique because it allows

▲ AutoPainter II Main Menu. ▲ Stopping mid-process. ▲ Portray Main Menu after applying Soft Sketch.

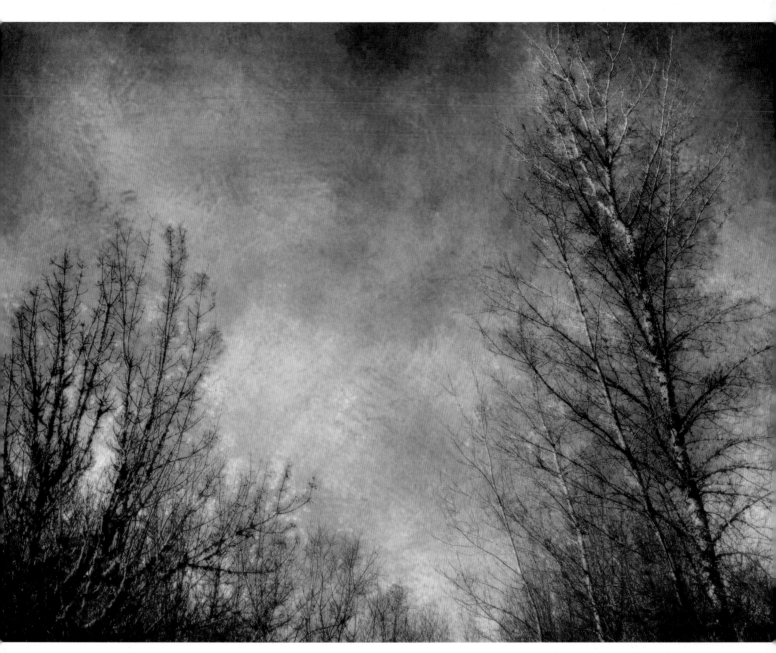

Winter's Light ● ProCamera, XnView Photo FX, AutoPainter II, Image Blender

you to apply an effect manually to parts of the image, rather than globally applying the effect to the entire image. After you've selected an image to edit, choose a starting preset effect. Try Soft Sketch for a black & white pencil look.

The Effects menu allows you to switch between artistic effects, intensity, contrast, colors, and paper types. Once you settle on an effect you like, you can make further adjustments. Tapping the Brush icon, you can paint over the image and it fills in the sketch on the paper. If you switch to the Eraser, you can erase portions of the image in the same way. Going over the same area multiple times increases the intensity of the effect. For the best control, use the Brush Adjustments to reduce the brush size and opacity before you start painting.

Illustration Effects

Illustration effects work well to bring contrast and definition or highlights to the edges of objects in your image. Illustration apps will convert your photograph to anything from cartoons and pop art to brushstroke outlines.

Tangled FX App

For a wide range of illustration styles, I turn to Tangled FX, which has both light and dark outline effects, fine tuning controls, and high resolution output (4096 pixels maximum). I especially like the effects that create a light outline, giving edges a glowing highlight. After loading a photo into Tangled FX, explore the options by tapping the different effects along the bottom of the screen. The app will quickly show you the effect in preview mode.

Fine Tune

When you find an effect you like, you can use the Fine Tune menu to make additional adjustments. Tap to open the menu, scroll up and down to see the available controls, then use the slider bars to make changes.

Suggested Apps for Illustration Effects
PhotoArtista—Haiku ToonCamera
Tangled FX XnSketch

To see the image as you make the adjustments, use the One Line View option. This makes the controls visible one at a time along the bottom so you can make your adjustments while seeing the impact on the image. Scroll up and down to move through the adjustment options, and tap to close the menu when you are done.

Full Resolution

When you are ready to save, change to full resolution by tapping on the Current Resolution setting. Tangled FX will reprocess the image at full resolution, which takes quite a bit longer, and then you can save it to the Camera Roll. If the highest resolution is not showing when you tap the current resolution icon, go into the Settings menu and increase the Full Size Resolution setting.

◀ **LEFT** – Tangled FX home screen.

◀ **CENTER** – Tangled FX Fine Tune menu.

◀ **RIGHT** – Tangled FX Fine Tune One Line View.

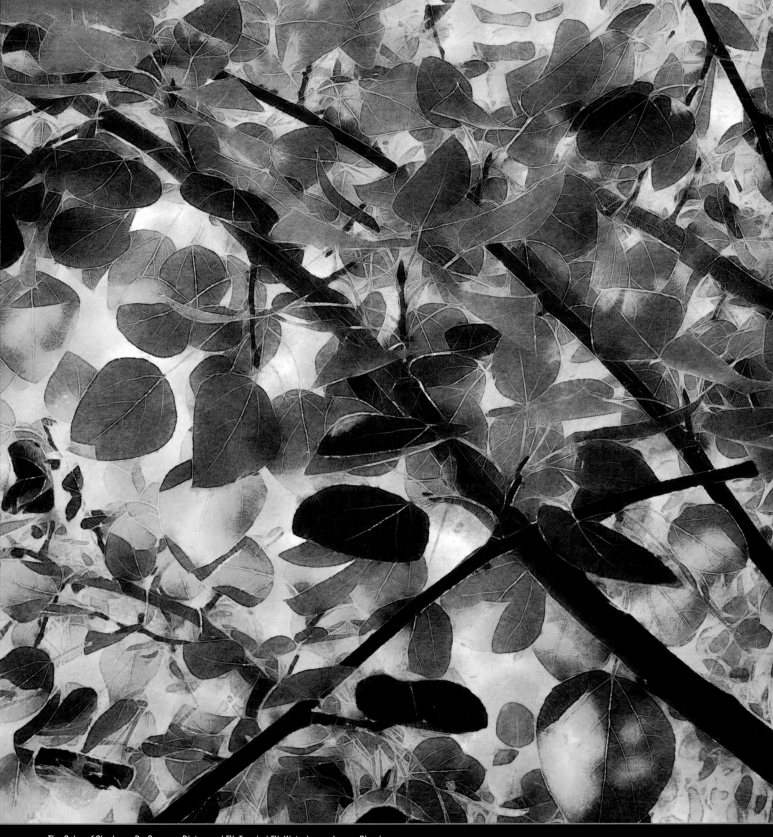

The Color of Shade ● ProCamera, Distressed FX, Tangled FX, Waterlogue, Image Blender

Geometric Effects

Approximating traditional mediums like drawing and painting is interesting, but there are apps that allow you to really embrace the unique capabilities of a digital medium. Some of these apps integrate geometric effects into your photograph, or convert your photograph into an image made up of geometric shapes.

Fragment App

The Fragment app adds geometric shapes to your image in a way that enables harmony in the final effect. Once you load and crop your photograph, you can select between a range of simple and complex shapes, called fragments, which are applied to the photograph. Using the randomize button allows you to explore many options quickly.

The fill of the fragment comes from the same photograph, and you have control of how the photograph fills the shape. Using the Quick Change icons, you can

Suggested Apps for Geometric Effects

Decim8	pxl.
DecoSketch	Percolator
Fragment	Tangent
GridFilter	XnShape

change the sampled location, the angle, and the magnification of the image within the fragment. You can use two fingers on the image, rotating and pinching, to change the angle and magnification of the image within the fragment, as well.

For more adjustments, tap the Adjustments icon at the bottom of the screen. From this menu, you can adjust the brightness, contrast, saturation, blur, color tone, and more—on either the original portion of the image or the added fragment. To switch between adjusting the original and the fragment, tap on the Switch Selection icon at the top of the screen.

I find the combination of geometric effects with natural elements creates a surprising and engaging contrast. Often, the simplest geometric effects are the most effective. Adding a simple geometric frame as in *Quiet, Revised* can focus and engage the viewer, because it doesn't fit normal assumptions.

▲ Fragment main menu.

▲ More adjustments.

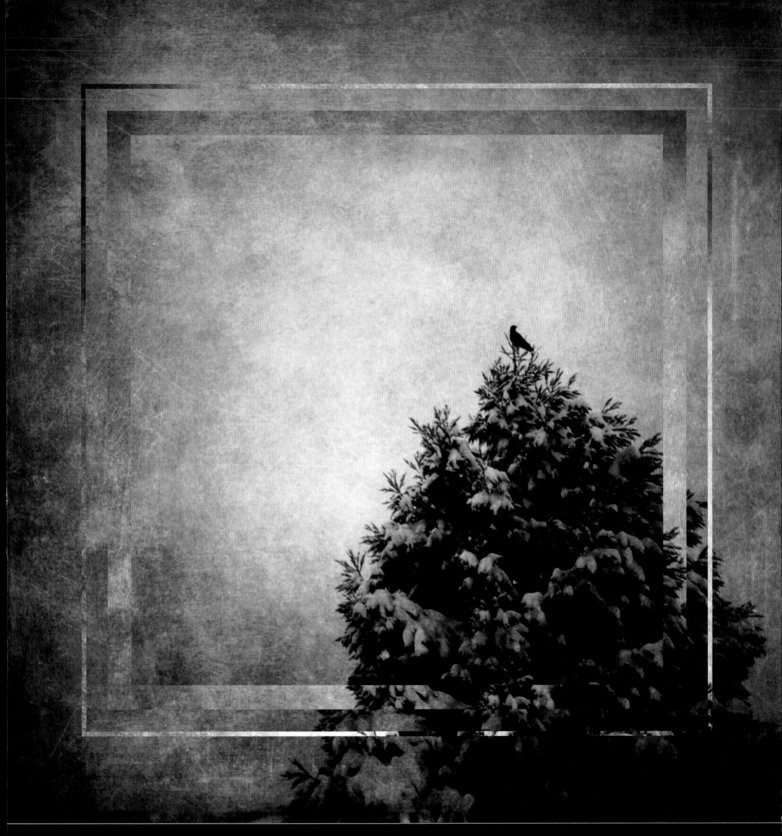

Along the same lines as geometric effects, glitch and distort effects provide uniquely digitized alterations to your photographs. Glitch refers to effects that are reminiscent of screen glitches you see when your computer goes haywire—striated, pixelated, and mixed up images. Distort effects allow you to warp, stretch, or deform an entire image or sections of it.

Decim8 App

My favorite app for glitch effects is Decim8. As with many of these types of apps, in Decim8 you can quickly shift from slight alterations to complete abstractions of a photograph depending on the number and type of effects you choose. After loading your photo, tap the Effects icon.

Within the Decim8 Effects menu, you can tap any individual effect to toggle it on and off. Tap the Info icon to see a preview of the effect applied to a sample image. When you want to try an effect, tap the Close icon to

Suggested Apps for Glitch and Distort Effects

Decim8	Glitchlab
Elasticam	Pixel is Data

return to the image. Tap the Process icon to apply the effect.

To explore stronger abstraction, apply multiple effects or use the randomize feature. Tap the Randomize icon to select two effects randomly, then tap the Process icon. If you like the result, you can always see which effects are active by returning to the Effects menu. If you like a combination of effects, you can save them as your own preset for future use.

Unlike many other artistic apps, Decim8 does not produce the same result each time you process an image with a given effect. Each time you apply the effect, the results are different. When you have multiple effects on at the same time, the variation is increased significantly. When you find a combination of effects you like for your photograph, I suggest you process the image several times, saving any and all results you like for future use.

To keep the images grounded in some reality, you may want to use only one effect—or blend an altered version of the image back with the original, as shown in the image *Double Vision*.

◀ **LEFT** – Decim8 Main Menu.

◀ **RIGHT** – Decim8 Effects Menu.

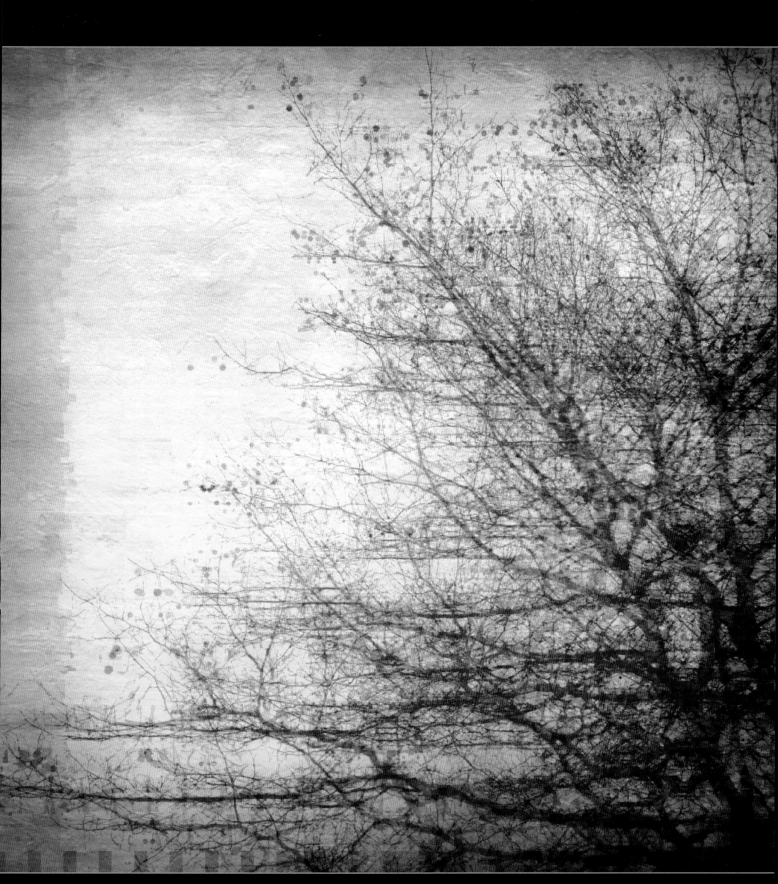

Double Vision ● ProCamera, Decim8, Distressed FX, Image Blender

Blur Effects

Sometimes you don't want to change your photograph dramatically, you just want to soften the focus and blur it a bit. There are all sorts of ways to blur a photograph. You can soften with an all-over blur or use bloom effects to give a hazy glow. You can imply motion with a directional blur. Selectively applying blur to the edges can give the impression of a toy camera or a tilt-shift lens.

Overall Blur

For an all-over blur, BlurFX is a great app. From the main menu you first select the Blur Type (Motion, Gaussian, or Median), then use the slider to adjust the strength of the effect.

You can mask portions of the photograph you don't want blurred. If you tap Show Mask, a red overlay showing the mask appears. Where it is red, the blur effect is applied. You erase the mask by coloring with your finger on the image when Clean is selected. To reapply the mask, slide the Blur/Clean switch to Blur. For fine control of the brush, you can adjust the brush size and edge with the Brush Size icon.

Other Blur Effects

For other types of blur, there are a range of apps I turn to. For a glowing blur effect, I use the Bloom option in XnView Photo FX or Glamour Glow in Snapseed. To approximate a shallow depth of field, I use the Snapseed

▲ BlurFX Main Menu.

▲ BlurFX Masking.

▲ Snapseed LensBlur Menu.

Lens Blur effect. In the Lens Blur option (found in the Filters menu), you set the focal point by tapping the image to access and move the blue dot. Once your focal point is set, use two fingers to zoom in or out to set the range of the image in focus, and then use the menus to set the width of the transition zone from sharp to blurred, and the strength of the blur outside the transition zone. You can switch between linear and elliptical

Suggested Apps for Blur Effects

| Big Lens | Snapseed |
| BlurFX | XnView Photo FX |

blur, as well as change the shape of the blur to approximate traditional lens bokeh.

Fallburst ● 6x6, Snapseed, Mextures

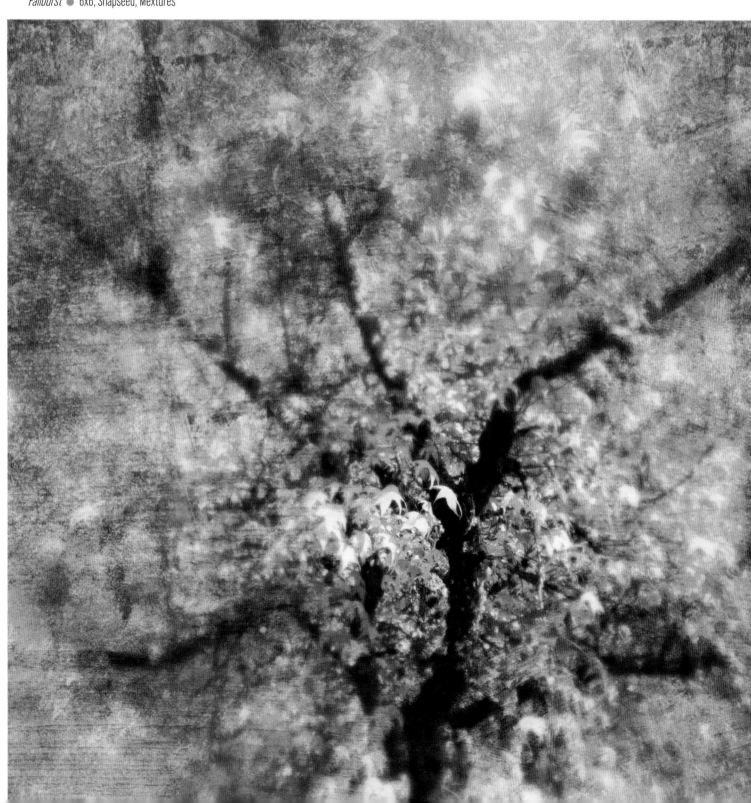

Vignette Effects

Often, the last thing I will do when editing an image is add a vignette, the gradual fading or darkening at the edges of a photograph. A vignette can serve to further define the edge of the frame, pointing the viewer's eye toward the center, or it can reduce distractions that come with high-contrast elements intersecting the edge of the frame. Vignette effects will lighten, darken, or blur the areas along the edges and corners of the image.

Many apps provide vignette options, and you will find that textures often approximate a vignette through wonderfully uneven edge effects. Most apps, however, don't provide much flexibility in adjustments between the center and edge brightness or the range of the vignette. Snapseed is the best app I've found for a highly controlled vignette.

Suggested Apps for Vignette Effects

Afterlight	Snapseed
BlurFX	Stackables
FX Photo Studio	VSCO Cam
iColorama	XnView Photo FX
Pixlr	

Snapseed's Vignette Effect

The Vignette effect in Snapseed can be found in the Tools menu. Move the focal point of the vignette by tapping on the image and moving the blue dot to center the vignette. You set the inner size of the vignette by using two fingers, pinching your fingers to bring the darker edges further into the image or spreading your fingers to push the darkness closer to the edges.

You can also adjust the relative brightness or darkness of the center and edge through the adjustment menu accessible when you slide your finger up and down on the image. (*Tip:* For a stronger effect, add edge blur along with a vignette, using Snapseed's Lens Blur.)

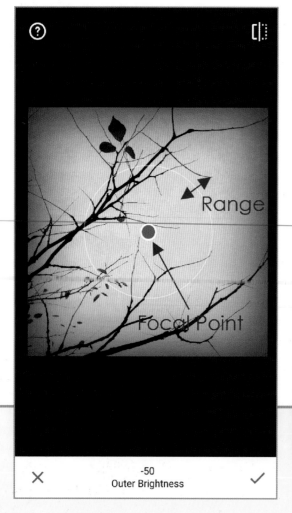

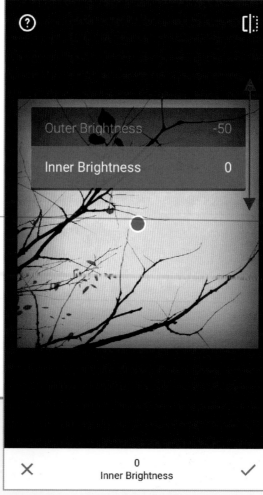

◀ **LEFT**–Setting the center.

◀ **RIGHT**–Further adjustments.

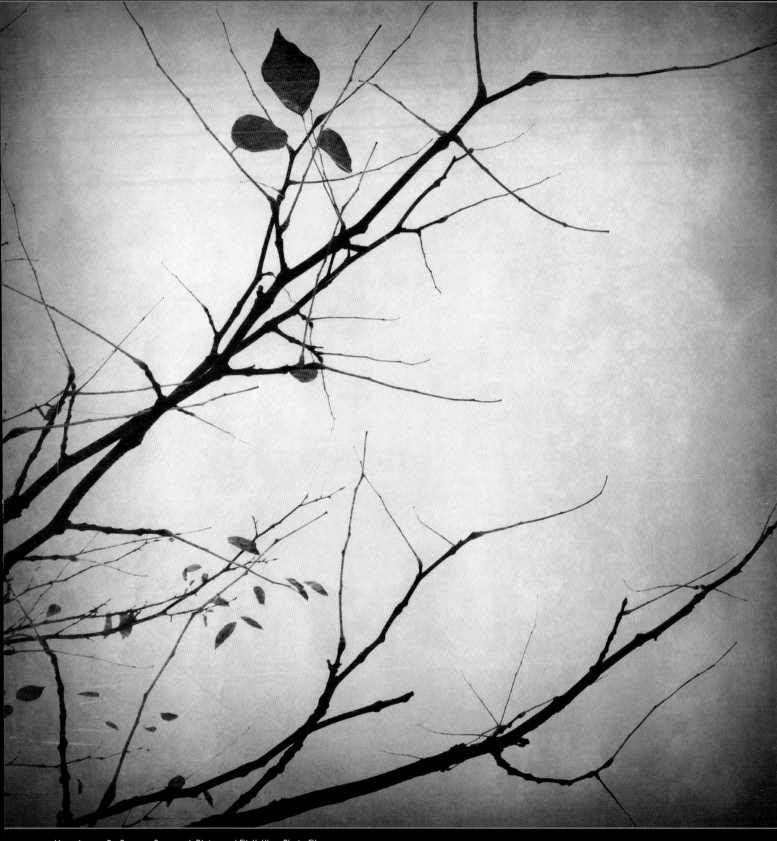

Lingering ● ProCamera, Snapseed, Distressed FX, XnView Photo FX

orders are a more dramatic visual clarification of the edge of a photograph than a vignette, often providing a finished look for the frame. Borders can provide a structured edge, ranging from a simple black stroke to effects that approximate different types of traditional photographic borders, such as instant film. Borders can also allow the imagery to show through, providing a darkened or lightened effect at the edge.

Pixlr App

For a wide range of borders, try Pixlr. After loading your photo, select the Borders menu and then select a submenu. Pixlr is loaded with a default set of borders, and you can download additional border submenus for more options.

Suggested Apps for Borders

Afterlight	Handy Photo
Alt Photo	Pixlr
Classic Vintage Photo	Snapseed
FX Photo Studio	

Scroll left to right through the border options and tap one to preview on your photograph. Once you select a border, you can apply a range of adjustments to fade the frame (reduce its opacity), flip the frame horizontally or vertically, and rotate. When you have completed your adjustments and like how your frame image looks, tap Apply.

◀ **LEFT** – Pixlr Borders menu.

◀ **RIGHT** – Border adjustments.

As a more dramatic or varied alternative to a vignette, I often use non-opaque textured borders. Since most apps apply borders by overlaying the photograph, an opaque border means I will lose the outer edges of the image, altering the effectiveness of the composition I carefully crafted in-camera. A non-opaque border preserves the edges of the composition.

I've also found opaque borders might look great when viewed online, because they provide a physical-looking edge, but this doesn't always translate well to printed presentations. It's always a good idea to save a version without the border as an option to use later, if desired.

Bedroom Light ●
ProCamera, Alt Photo, Pixlr

While it's fun to experiment with lots of different apps and effects, it can be overwhelming to learn so many different interfaces at one time. A good place to start is with a full-featured app, which allows you to do much of your editing within a single interface and session. These apps incorporate basic adjustments, color filters, textures, artistic effects, borders, and more—providing significant creative flexibility for a single investment of time and money.

iColorama App

Many of the apps covered in the previous sections are full-featured apps, from which I've highlighted a single feature or effect. One additional full-featured app to consider is iColorama. After loading an image, you select an effect menu by tapping Select on the top menu bar. For example, the Tone menu provides options of color filters, while the Style menu offers artistic effects.

Suggested Full-Featured Apps

FX Photo Studio Snapseed

iColorama Stackables

Pixlr

Once you have selected an effect menu, you scroll through the options along to the top to select a sub-menu. Within the sub-menu, there are additional selections in the form of Presets. Tap the Preset icon and another set of options will appear. Scroll the list of presets, up and down, and tap any of the entries to preview the image. When you find an effect you like, tap the Preset icon again to make the menu disappear.

Once you've selected your effect, you have more adjustment flexibility. Opacity and other setting adjustments that are available for the selected preset show up

▲ iColorama Effects menu.

▲ iColorama Preset menus.

▲ iColorama Adjustment options.

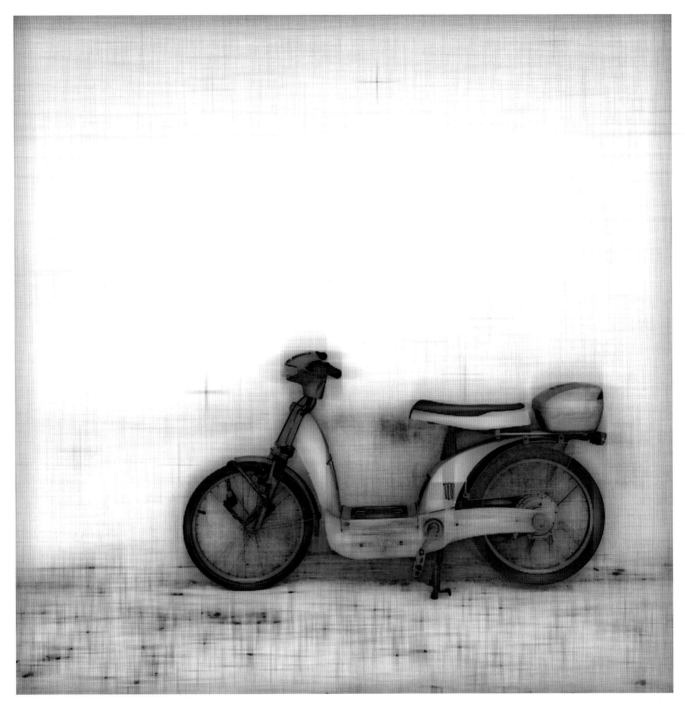

Sweet Ride ● ProCamera, iColorama

along the bottom. Reducing opacity is a great way to subdue the look of a chosen effect. You can also selectively apply the preset using a mask. Tap the Show/ Hide Mask Menu icon to open or close the Mask menu. Once you've made all of your adjustments, tap the Apply icon on the top menu bar to process the image.

You can apply multiple effects in sequence and iColorama provides a history feature, which allows you to see each of the steps you've made in your edit. You can go back to any previous point in your editing sequence by tapping the Steps icon on the top menu bar, then double tapping the step to which you want to return. You can play with alternate effects and return to any of the later steps until you tap Apply with a new effect, which commits you to a new sequence of steps.

Now that you understand a number of different apps and the effects available, it's time to get creative and combine them. The simplest way to edit with multiple apps is to sequence them, taking the output from one app and processing it in another app. The following is a simple example of how app sequencing works.

The Simplest Way to Edit

Start with an image and complete any basic adjustments in Snapseed. For example, an underexposed image may need brightening. Next, the color tones are changed with the application of a color filter and texture (for the image in this example, I used Distressed FX). Finally, apply a painterly effect. Here, I used the Glaze app to product the painterly effect seen in the final image, *Stand Tall*.

The final image (*facing page, top*) is significantly different from the starting image (*top left*)—but the transformation took only a few steps. By sequencing apps, each step slightly alters the photograph, increasing the variation and the results of the applied effects in the next app. For example, simply by applying the Glaze app directly to the starting photograph (without sequencing the apps), I achieve a very different result (*facing page, bottom*).

Unique Looks

In iPhone photography, the combination of multiple apps in sequence will lead to a unique style in your work over time. By favoring certain apps and applying them in a specific order, your work will be different than others. Even within your own work, you may find

◄ **TOP**–Starting Image.

◄ **BOTTOM**–Starting Image through Distressed FX.

Stand Tall ● ProCamera, Distressed FX, Glaze

that you choose different apps and sequences depending on your evolving moods or interests. The range of styles that emerge from variation and experimentation with app sequencing is part of the fun and creativity to be found in this medium.

▶ Using the Glaze app directly on the starting photo (without sequencing the apps) yields a different result.

Sequencing adds incredible variety to post-processing, but I find it's blending multiple images where the magic truly happens. Blending is when you take two images, either two distinct images or two variations on the same image, layer and combine them. You can either tone down an effect created in an artistic app, or create a dramatic alteration to the original photograph.

Image Blender App

Image Blender is the app I use for blending images using my iPhone. The next few sections will show you how to use this app as well as give you some background on blending modes so you can better use them in your editing.

The first thing you need to do in Image Blender is load two images. Tap the left image icon to load the bottom image, or layer, of the stack; tap the right icon to load the top layer.

Once you have two images loaded, you can use the opacity slider to adjust the effect of the blending mode. The initial settings are always Normal blending mode at 50 percent opacity. To change the blending mode, you tap the Blend Mode menu icon. Slide the menu left to right to view the options and tap a mode to preview it on the screen. When you find a mode you want to apply, tap the Blend Mode menu icon again to close the menu and apply the selected mode. Now you can adjust the intensity using the opacity slider.

When you like the effect, tap the Export icon to Save or Flatten your image. For both Save and Flatten, the app applies the blend mode settings, combining the two images into one new image file. With Save, the new image file is exported to your Camera Roll and the original top and bottom images are still available in the app. This works well if you want to continue experimenting with blend modes on the same set of images. With Flatten,

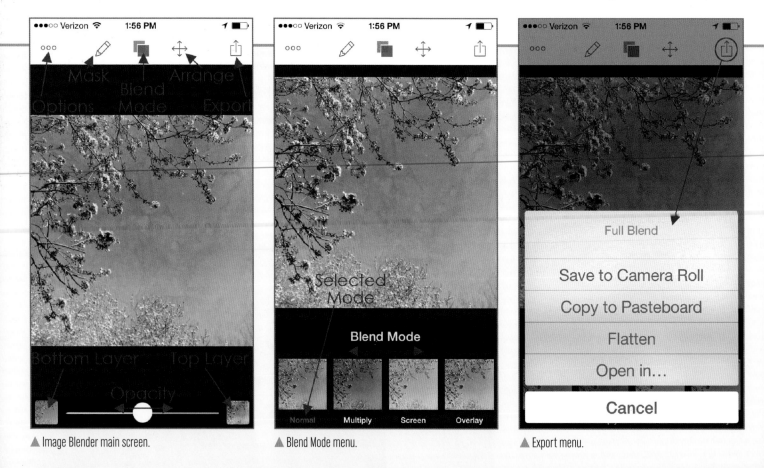

▲ Image Blender main screen.　　　▲ Blend Mode menu.　　　▲ Export menu.

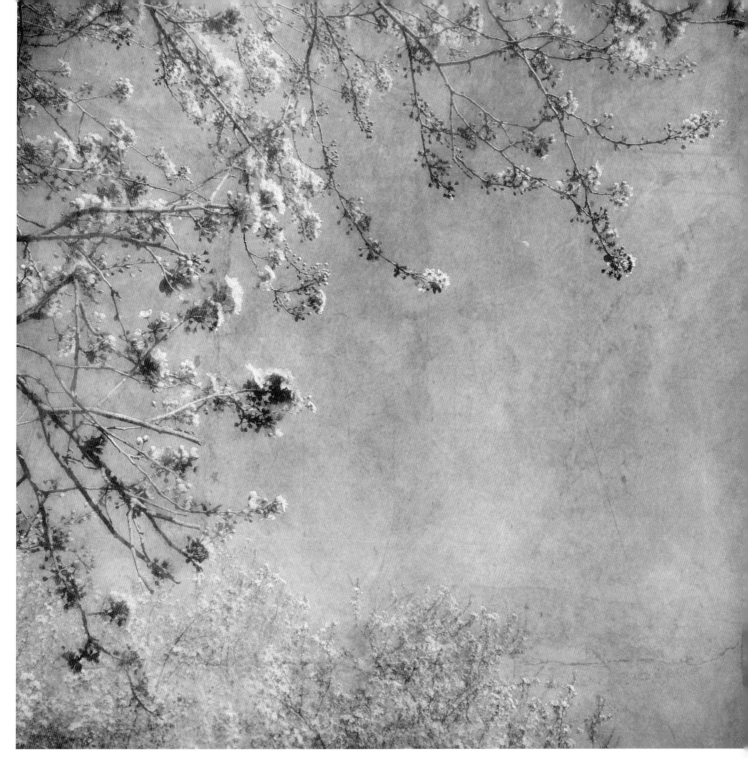

Springing it on Me ● ProCamera, Snapseed, XnView Photo FX, Distressed FX, Repix, Image Blender

the two images are combined into the bottom layer in the app. This works well if you want to load a new image to the top layer, blending in a new effect. I like to first Save each blended image so I have it available for future use, and then Flatten if I want to blend another layer.

Other Apps

Other apps, like Stackables, Mextures, and iColorama, also have similar blending features within them. Keep an eye out for this functionality within the apps you use.

While blending creates wonderful effects, you may not always want to blend two images in their entirety. You may want to preserve parts of the bottom image without blending, or change the orientation of the top image relative to the bottom. When that's the case, you can take advantage of the Mask and Arrange functions within the Image Blender app.

Mask Function

To prevent part of the top layer from blending with the bottom layer, use the Mask function. To do this, tap the Mask icon to open the menu. Using the brush to paint over the image defines the mask, which removes the top layer so it will not blend with the bottom layer. If you find you have masked (eliminated) too much, tap the Mask/Erase icon to switch between the Mask and Erase modes. Then use the eraser to fill back in the erroneously masked areas.

For finer control of the mask, you can adjust the brush size in the settings menu and refine the brush type. To change the brush, tap on the Brush Type icon. You can select between a hard or soft edge on the brush, as well as straight or circle gradient. Gradients are useful to create a controlled linear or circular transition for blending one image into the other.

Arrange Function

When the top image is not at the right size—or at the preferred orientation—relative to the bottom image, you can use the Arrange function to correct the problem. To quickly adjust the top image, tap the Arrange icon and use two fingers to enlarge, reduce, or tilt the top image relative to the bottom image. Tap the More Options menu at the bottom to access additional functions such as flip (horizontal only), lock, and precision scaling or rotation.

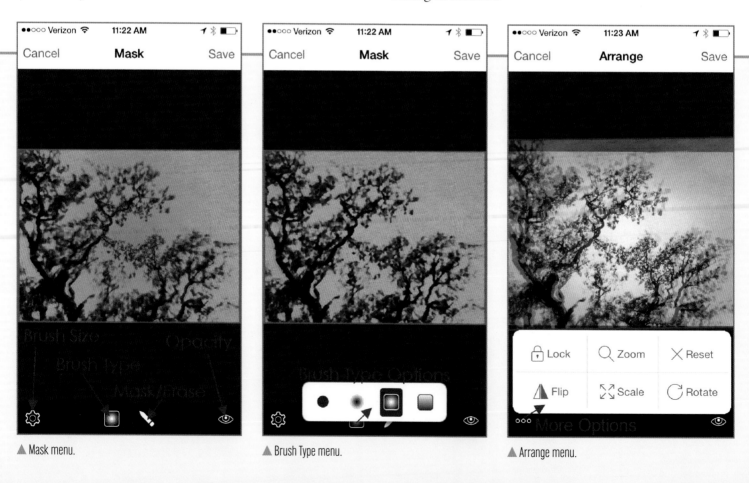

▲ Mask menu.　　▲ Brush Type menu.　　▲ Arrange menu.

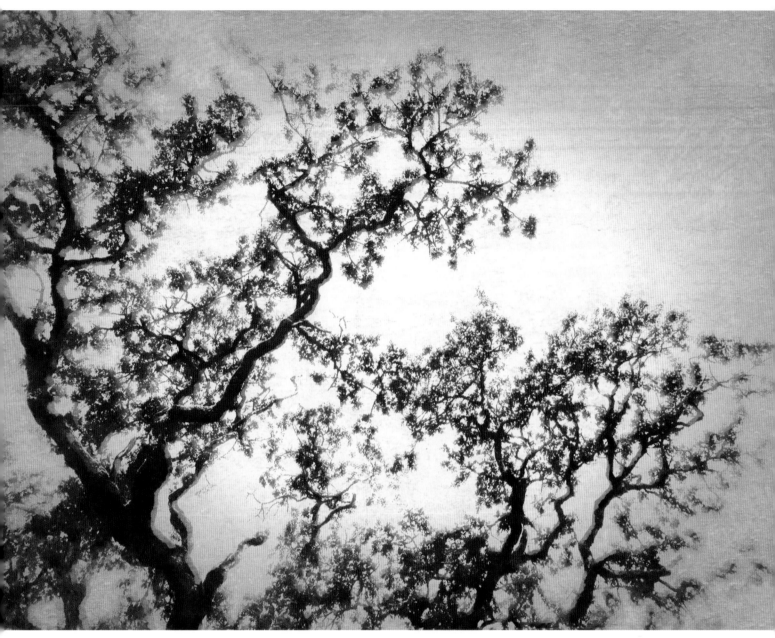

Summer Oak ● ProCamera, Snapseed, Distressed FX, Pixlr, Image Blender, AutoPainter II, Portray, SketchMee

Opacity Adjustments

In both Mask and Arrange menus, the Opacity icon allows you to adjust the opacity of the images within the menu, so you can see what changes you make to the top image relative to the bottom image.

Resetting Mask and Arrange

The Mask and Arrange settings will persist throughout a session, even if you load a new image in the top or bottom layers. You can easily reset these settings. Tap either the top layer or the Options icon, select Reset and then choose to reset either Mask or Arrange.

lending modes are not random. They are mathematical functions that combine the pixels of two stacked layers to create a visually altered result. You don't need to know the math behind blending modes to learn and control their visual impact.

Top or Bottom?

In most cases, the visual result of a blend will vary depending on which layer is at the top or bottom. To test this, select any blending mode except Normal (the only blending mode that yields the same result regardless of which image is the top or bottom layer) and set

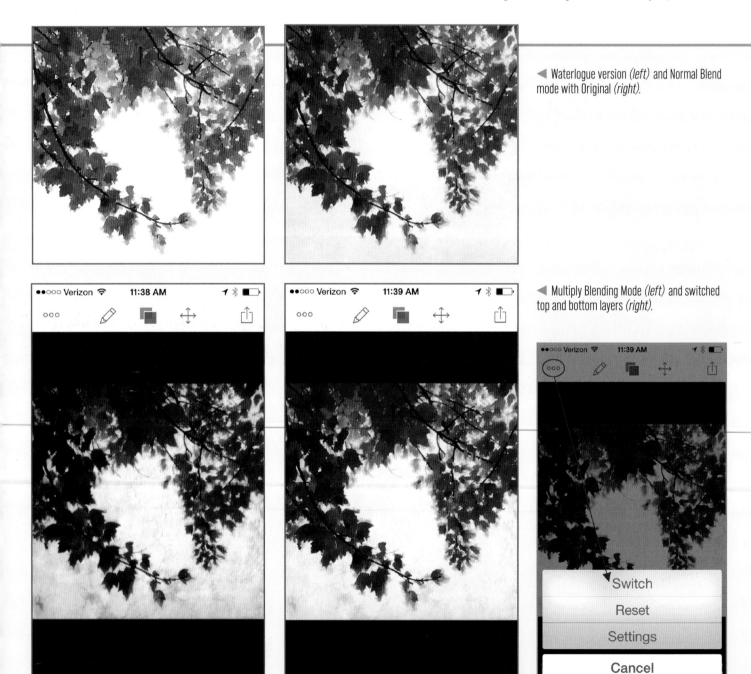

◀ Waterlogue version *(left)* and Normal Blend mode with Original *(right)*.

◀ Multiply Blending Mode *(left)* and switched top and bottom layers *(right)*.

▲ Switching the top and bottom images.

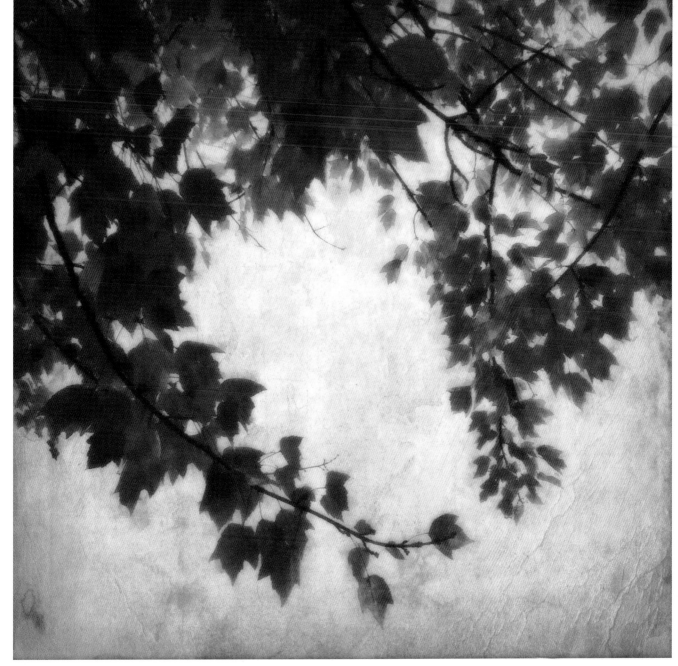

Heart of the Fire ● ProCamera, Distressed FX, Image Blender, Classic Vintage Photo, Waterlogue

the opacity to 50 percent. Save the results. Now switch the images and save again. Compare the two images. Do you see a difference?

Switch the Layer Order

To quickly switch the top and bottom images, you access the Options menu at the top of the screen and tap Switch. The current blending mode and opacity settings are retained, but the images are switched between top and bottom layers.

Variations and Refinements

The variety of image effects you can achieve with blending modes is fantastic. There are eighteen blending modes within Image Blender to start, and you almost double that when you consider that switching the top and bottom layer produces a different result in seventeen of the modes. You can also tone down any effect, return the structure from the original photograph, or blend the processed image back with an original version using Normal mode.

Blending Modes for Lightening

There are several blending modes that primarily lighten or brighten an image. For these blending modes, the pixels of the bottom layer are lightened based on the lightness of the pixels of the top layer.

There are four lightening modes in Image Blender, listed in order of increasing effect: Lighten, Screen, Plus Lighter, and Color Dodge. Color Dodge is the most extreme effect of the four, significantly increasing the color saturation and contrast, as well as lightening.

You can also use these modes to add a subtle texture by using a texture image as the top layer.

The following examples show the effect of each type of blend, with two different starting images. The opacity was set to 50 percent for each example.

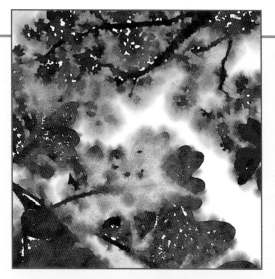

◀ **LEFT**–Starting image (bottom layer).

◀ **RIGHT**–Starting image (top layer).

▲ Lighten mode.

▲ Screen mode.

Vivid ● ProCamera, Snap-
seed, Distressed FX, Image
Blender

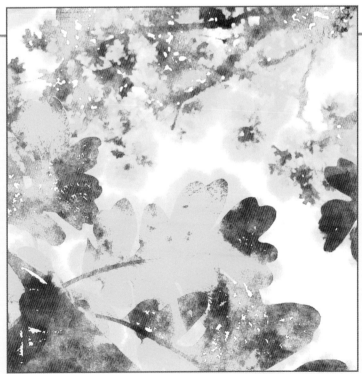

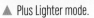 Plus Lighter mode.

▲ Color Dodge mode.

Blending Modes for Darkening

Of course, if there are blending modes for lightening, there must be blending modes for darkening, too. In these modes, the pixels of the bottom layer are darkened by the relative darkness of the top layer's pixels. The four darkening modes in the Image Blender app, in order of increasing effect, are Darken, Multiply, Plus Darker, and Color Burn. Similar to Color Dodge, Color Burn intensifies the colors as well as darkening.

The following examples show the effect of each type of darkening blend mode, with two different starting images. The opacity was set to 75 percent for all.

Use these modes to darken and intensify the colors in an image. You can also add dramatic texture by blending a photograph as the bottom layer with a texture image as the top layer.

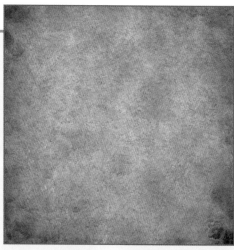

◄ **LEFT**–Starting image (bottom layer).

◄ **RIGHT**–Starting image (top layer).

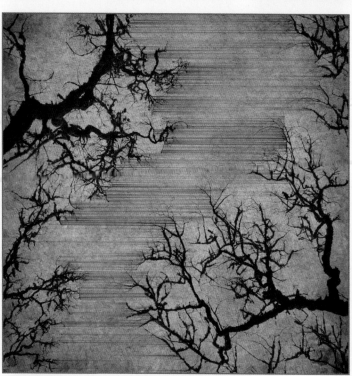

▲ Darken mode.

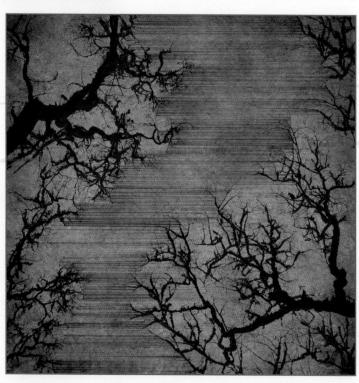

▲ Multiply mode.

Silent Communication ●
ProCamera, Glaze, Auto-
Painter II, Image Blender,
Decim8

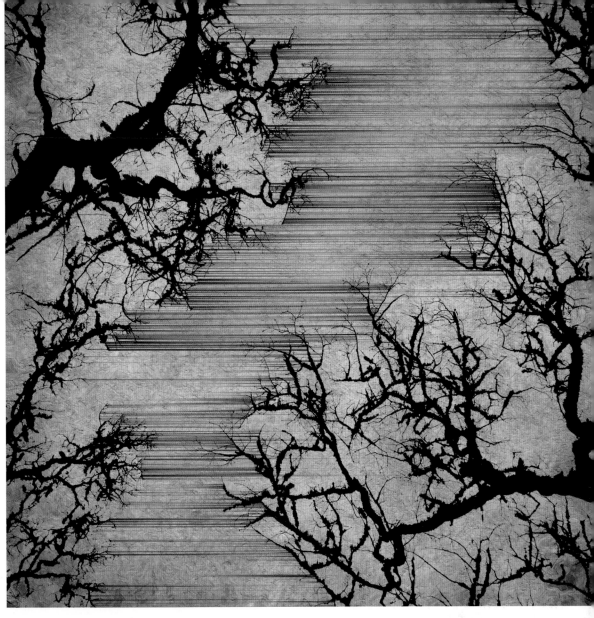

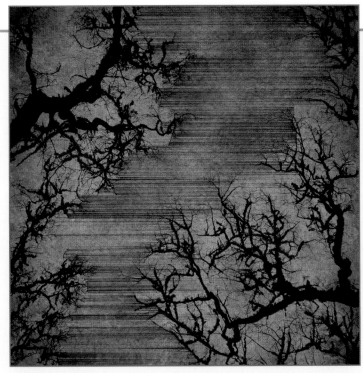

▲ Plus Darker mode.

▲ Color Burn mode.

oft Light, Overlay, and Hard Light are the modes to use when you want to increase the contrast, or overall range of light and dark, of an image. In these modes, for the lightest of the pixels in your top layer, you lighten the pixels in the bottom layer. For the darkest of the pixels in your top layer, you darken the pixels of the bottom layer.

These modes are the typical modes you would use to blend an original with a texture image because you get the effect of the texture without dramatic shifts in color.

As an example, the images here show the resulting blend of a photographic image on the bottom with a texture image on top. The opacity was set to 75 percent. The texture image was created by photographing a cracked plaster wall.

Don't restrict yourself to using these blending modes with textures only. The Contrast modes also works great when blending variations of the same image together.

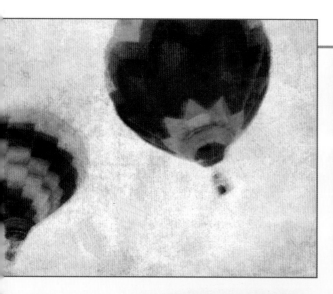

◀ **LEFT** – Starting image (bottom layer).

◀ **RIGHT** – Starting image (top layer).

▲ Soft Light mode.

▲ Overlay mode.

Lighter than Air ● Slow Shutter Cam, Handy Photo, Snapseed, XnView Photo FX, Image Blender, Distressed FX, and AutoPainter II

▲ Hard Light mode.

Blending Modes for Shifting Color

For more dramatic and surprising effects, you can use blending modes to shift the color. In this category, I include two comparative blending modes (Exclusion and Difference) as well as the color blending modes (Hue, Saturation, Color, and Luminosity).

Color blending modes are useful when you want to affect one attribute of color without affecting the others in an image. To understand the color blend modes, you first need to understand the attributes of color in digital editing: hue, saturation and luminosity. Hue is the color value (red, blue, green, etc.). Saturation is the intensity of the color. Luminance is the brightness, or relative lightness/darkness of a particular color, ranging from black (no brightness) to white (full brightness). In each of the four color blend modes, you take some of the color attributes from the top layer and the others from the bottom layer.

The comparative blending modes, Exclusion and Difference, transform color by inverting the colors of the bottom layer relative to the colors of the top layer. For the most intense color-shifting effect, use these modes with two different images rather than the same image blended on itself.

The examples shown here blend two different starting images in the four color blend modes and the comparative modes. The opacity was set to 75 percent.

◄ **LEFT** – Starting image (bottom layer).

◄ **RIGHT** – Starting image (top layer).

▼ Hue Mode.

▼ Saturation mode.

▼ Color Mode.

Breaking Down ● ProCamera, Snapseed, Handy Photo, Image Blender

▼ Luminance mode.

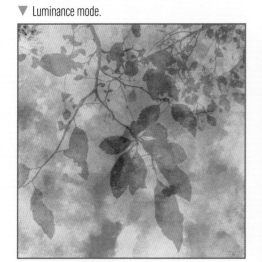

▼ Difference mode.

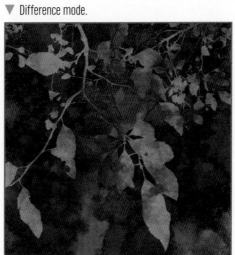

▼ Exclusion mode.

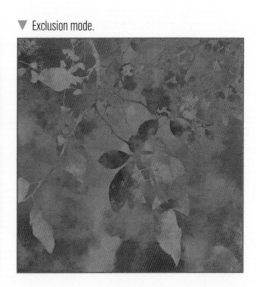

Putting It All Together

Now you know the basic building blocks of creating photography-based iPhone art: a photograph, photo editing apps, and blending. You can combine these building blocks in infinite ways, which keeps the process fun and spontaneous—and makes the resulting art unique. Let's walk through the creation of *Good Evening*, so you can see how a finished image is built from the three basic components.

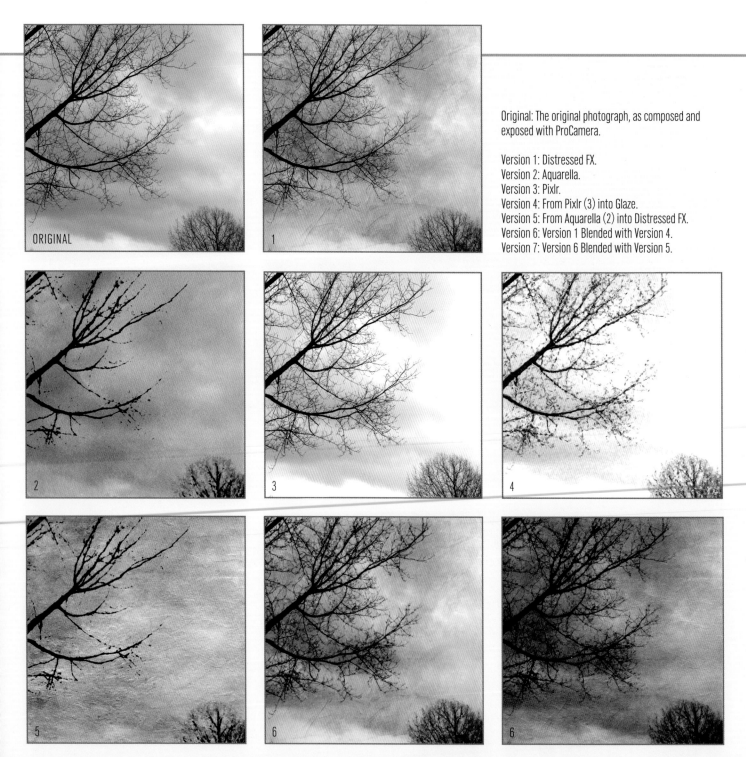

Original: The original photograph, as composed and exposed with ProCamera.

Version 1: Distressed FX.
Version 2: Aquarella.
Version 3: Pixlr.
Version 4: From Pixlr (3) into Glaze.
Version 5: From Aquarella (2) into Distressed FX.
Version 6: Version 1 Blended with Version 4.
Version 7: Version 6 Blended with Version 5.

Good Evening ● ProCamera, Pixlr, Glaze, Aquarella, Distressed FX, Image Blender

First, I played with the image in editing apps. As I tried different options *(1, 2, and 3)*, I saved the ones I liked. This experimentation points me toward a mood, color scheme, or effect that fits a specific image. In this case, I was attracted to shades of gold and pink.

Next, I sequenced the apps, to add texture and variation by the application of multiple effects *(4 and 5)*. I blended these different sequenced versions together using Image Blender *(6 and 7)*.

To complete *Good Evening*, version 7 was blended with version 1, which brought back the photographic structure of the trees while keeping the color and texture created through the editing sequence. The finished piece could only have been achieved through the combination of sequencing and then blending multiple apps. No single app would have created the subtle color and texture variations observed in the final version.

One of my favorite things to do is combine multiple texture apps together, either through sequencing or blending, which creates a striking result. The piece *Imminent Downfall* is a good example of how quick and easy it is to achieve this type of texture effect.

The image started as nothing exceptional, a photograph of an autumn tree. I liked the curving lines of the

lower branches, but because there is no zoom lens on the iPhone, this was the closest photograph I could get to those branches.

I used Snapseed to crop, lighten, and adjust the color with the Grunge filter *(1)*. After cropping significantly like this, it is good to increase resolution in Big Photo before continuing to alter the photograph.

After playing with a few options, I liked the color contrast of the leaves against the background in version 4. To soften the edges and add a subtle color-bleed effect, I blended it with the output from Waterlogue *(3)*. This also brightened the color in the leaves.

For an even stronger texture and to warm the image, I added a crackle texture using XnView Photo FX. The result was a complex and interesting texture.

Original: The original photograph, as composed and exposed with ProCamera.
Version 1: Snapseed.

As the next step, I experimented with processing version 1 in different apps.

Version 2: Version 1 through Stackables.
Version 3: Version 1 through Waterlogue.
Version 4: Version 1 through Classic Vintage Photo.
Version 5: Version 4 blended with Version 3

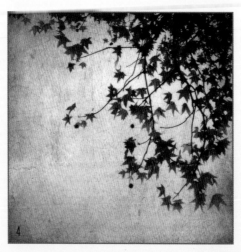

ORIGINAL

1

2

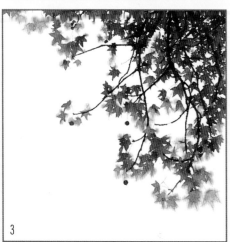

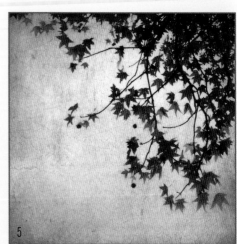

3

4

5

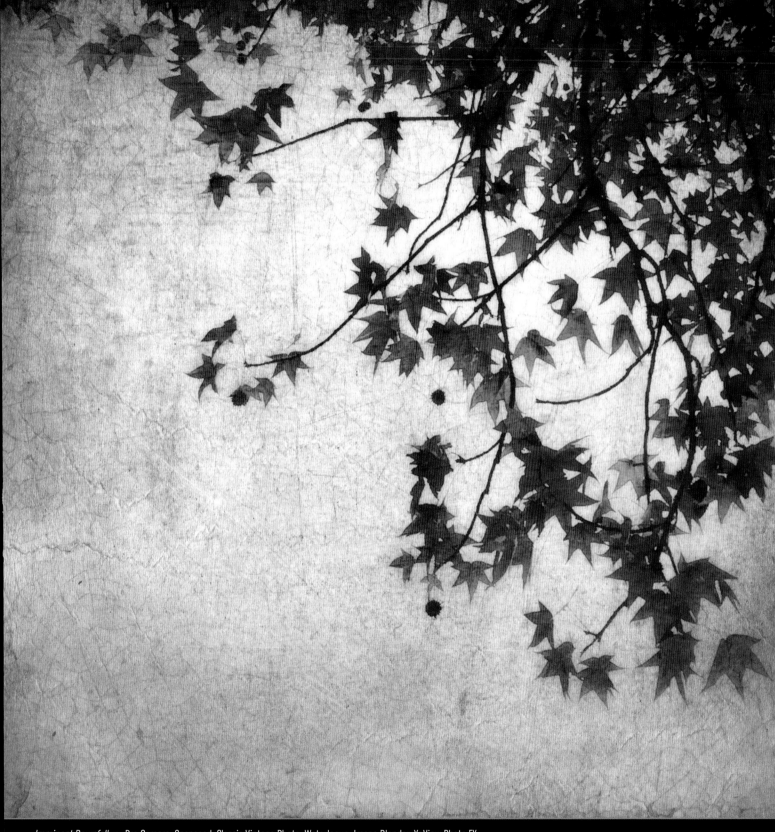

Imminent Downfall ● Pro Camera, Snapseed, Classic Vintage Photo, Waterlogue, Image Blender, XnView Photo FX

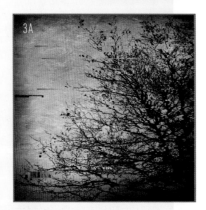

My process for creating art with iPhone photographs does not rely on a logical or predetermined sequence of steps. Most of my work involves creating possibilities for a piece by using multiple apps, then following one of the many branching paths. I may get several steps down a path and realize it's a dead end, go back to a previous point, and move off in a different direction. It's only at the end—when I have a finished piece—that I can trace a clear path from the original to the final image.

In order to keep each piece visually unique, I normally complete one finished work per starting photograph. Occasionally, however, the possibilities branch and result in two finished works. *Dissolution* is one of two finished pieces that came from a single original. The original photograph, a tree silhouette against the grey Oregon sky, is shown to the left.

After converting the shot to black & white and increasing the contrast in Snapseed *(1)*, I played with the image in Distressed FX *(2)*.

When I found a color and texture I liked, I explored options in Decim8. Since Decim8 effects are random, I ran the filter multiple times. When a result looked interesting, I saved it and repeated the filter. I ended up with multiple images saved to my Camera Roll as possibilities *(3A through 3D)*.

Next, I blended the options from Decim8 back with version 1 in Image Blender. I created and saved multiple versions of blends from Im-

Original: The original photograph, as composed and exposed with ProCamera.
Version 1: Snapseed.
Version 2: Version 1 through Distressed FX.
Versions 3A-3D: Version 2 through Decim8.
Version 4: Version 1 blended with version 3D.

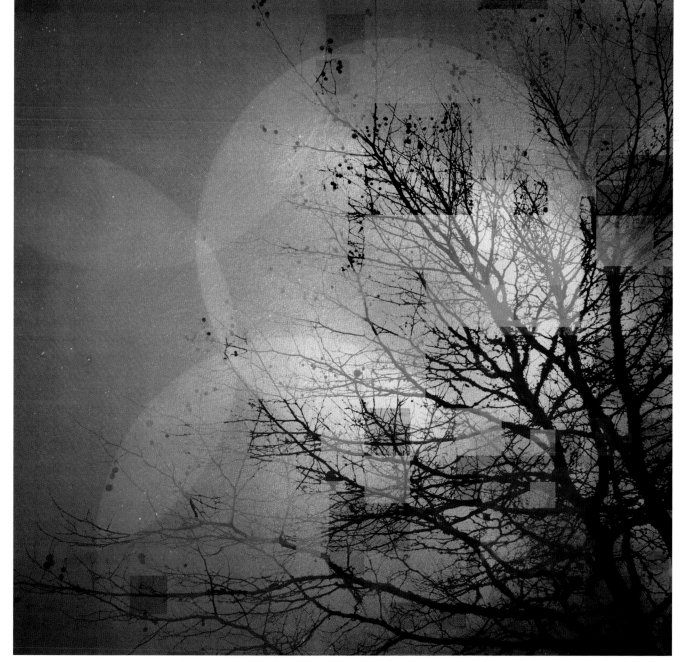

Dissolution ● ProCamera, Snapseed, Decim8, Image Blender, Lumiforms

age Blender, one of which is the black & white version below seen in version 4. To create this look, I used the black & white photograph *(1)* as the bottom layer and a Decim8 version *(3D)* as the top layer. These were blended in the Luminosity mode.

I combined version 4 with a separate background image file (backgrounds are covered in the next section) to complete *Dissolution*.

An Alternate Version

An alternate version with the same starting image was seen in section 36. Titled *Double Vision*, this variation was created through a different branch of blending where multiple versions from Decim8 were blended to create a blurry, digitized, but still recognizable tree. It started with the same image and editing sequence, yet yielded a different look.

Creating Backgrounds

ORIGINAL

A

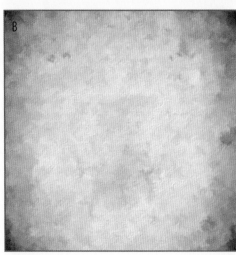

B

C

▲ Felicity texture by Kim Klassen (original). Texture image processed through Glaze (A), PhotoArtista – Oil (B), and AutoPainter II (C).

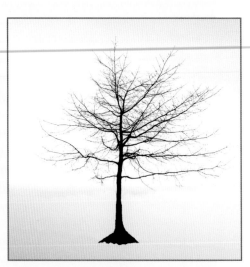

▲ Completed background.

▲ Photograph, created separately.

Now that you have the basics of sequencing and blending apps down, I'll share a few of the more complex combinations I use in creating my iPhone art. One component in many of my images is a background that is created separately from the main image. To be used as a background, the image should consist mainly of subtle texture and color variations instead of a distinct subject.

For *Vanishing*, the background started as a texture image file. I've collected a number of texture images over time from various sources, but I also create my own starting texture image files by photographing various surfaces such as concrete, paint, screens, and so on.

You can also use artistic apps to alter your texture images (just like you would process photos), smoothing out any sharp edges and adding some nice variations. Processing the texture file through multiple artistic apps will increase your options for later blending. While I didn't need to alter color in this case, you can also alter the color of your background by using

Vanishing ● ProCamera, Image Blender, Glaze, AutoPainter II, Handy Photo, Decim8

color filters. Once created, backgrounds can be reused multiple times.

To achieve the effect shown in *Vanishing*, I created the tree image separately by removing a tree from a photograph and converting it to black & white. Then, I blended it with the background. The top layer was the tree image and the bottom layer was the background image. I arranged the tree image off center and blended the layers using a darkening mode (such as Color Burn). To complete the piece, I added horizontal lines by processing the blended image with the Decim8 app.

Using Backgrounds to Alter Color

Color and texture are dramatically altered using the Difference and Exclusion blending modes. To create *Layered Autumn,* I used three photographs: an autumn tree as background *(A)*, a close-up of autumn leaves from a different tree as detail *(B)*, and a cracked plaster wall as texture *(C)*.

The background image was created from the autumn tree image *(A)* using the Portray, AutoPainter II, Aquarella, and Image Blender apps. This new background image suggested an autumn tree, retaining the color and rough structure without the distinct edges. With this background as the bottom layer and the leaf close up *(B)* as the top layer, I blended using the Exclusion mode in Image Blender. Because the colors are most altered where they are different, the leaves retained a yellow-red color while the sky shifted to a complementary color. I also used Image Blender to combine the cracked plaster wall image *(C)* with this new composite. The cracked plaster wall image was arranged so that the cracks did not distract from the underlying leaves.

To achieve the final look, I blended several additional subtle texture files into the image, increasing the color and texture variation.

The complexity achieved by blending multiple images and textures together can take a photograph from flat to nuanced and interesting. The depth draws viewers in. They are not sure what they are seeing—is it a photograph or something else?—so they look closely to discern the details.

▲ The starting images.

▲ The background image.　　▲ Image B over background, Exclusion mode.　　▲ Previous image blended with image C for texture.

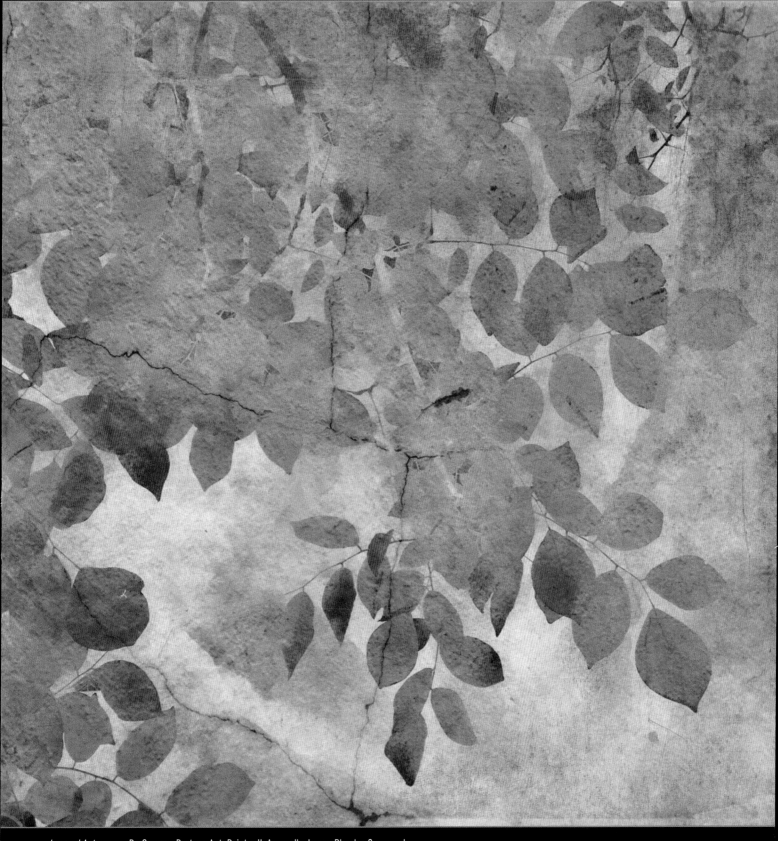

Layered Autumn ● ProCamera, Portray, AutoPainter II, Aquarella, Image Blender, Snapseed

An out-of-focus photograph is another way to achieve a soft, subtle effect for a background image. In the image *Dyed for Spring*, a blurry photograph of tulips serves as the background image for the tulip silhouette.

Shooting Out of Focus—On Purpose

Creating an out-of-focus image with an iPhone is not easy, since almost every camera app has autofocus built in. You can use the F/E Lock in ProCamera (as was described in section 7) to override the autofocus for a blurred image. In this case, I achieved a nice soft focus look by shooting with an aftermarket macro lens at a greater distance from the subject than was intended.

Blending and Positioning

I blended the silhouette tulip (bottom layer) and out of focus background (top layer) using the Exclusion mode at less than 100 percent opacity. This allowed some of the color variation from the background to be retained in the open space of the silhouette image. I arranged the background image so that the blurry tulip shape in the background overlaid the tall, focal point tulip. This creates a harmonious result as the shapes from the background replicated the shapes in the silhouette image.

Adding Textures

Again, the final image was achieved by blending in multiple additional textures. The yellow-green background color came from one of those textures. While you can always use texture apps to add and blend in these additional layers, I also use Image Blender with individual texture files I've created or collected. Having multiple sources of textures adds variation and interest to your work over time.

 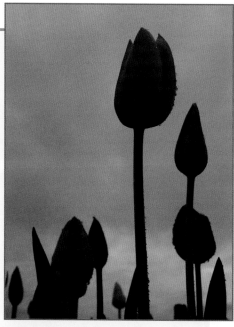

▲ The two starting photographs.

▲ Arranging background relative to the silhouette.

▲ Before and after Spot Adjust.

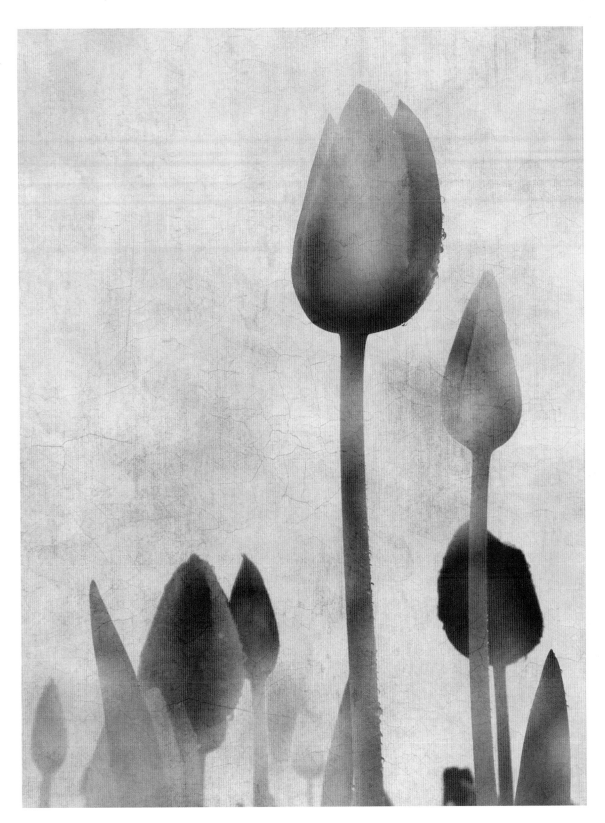

Spot Adjustment

This image needed one final adjustment. The blue-green area in the lower left of the image was lighter than the rest of the colors, and the difference created a distraction. Using Snapseed's Spot Adjust function, the area was darkened and the distraction reduced. Don't forget you can use the basic editing techniques and apps on a processed image as well as on your starting photograph.

There are times when you want to extract a specific element from a photograph for use separately, such as creating a graphic element to blend with a new background or removing an interesting element from a distracting scene for processing on its own.

Handy Photo

Handy Photo can be used to cut out elements of an image, save them as a new file, and move them to another image for further processing. For best results, start with an image where your graphic element can be easily removed from the photograph. In this example, I photographed fallen leaves on a simple, asphalt background.

Making Selections

Use the Handy Photo Move Me function to cut the element out. To start, use the Lasso to circle the element you want to cut. Then tap the Autoselect icon to have Handy Photo automatically select the element. Autoselect works best when your element has a good contrast with the background and large features. If portions of the element aren't correctly highlighted after using Autoselect, you can manually use the Brush and Eraser to refine your selection.

Moving or Duplicating

Once you have your element correctly highlighted, you can move or duplicate it. To remove the background, tap the Move icon. Handy Photo will process your selection, and then you can choose how to layer it. You have the option to export the selection with a transparent background (PNG file) or to layer it on a new background. I often choose

A Solid White Background

To create a blank white background, take an overexposed photograph of a blank white surface and increase the brightness in Snapseed.

▲ Starting image.

▲ Handy Photo Move Me menu.

▲ Handy Photo, Select Layer Menu.

▲ Cut element.

In Memoriam ● ProCamera, Handy Photo, Image Blender, Tangled FX, XnSketch, Waterlogue, AutoPainter II, Stackables

to move my element to a solid white background for further blending and processing, using the Move to New Image feature. The selection is placed on the white background, and then you can arrange and resize as desired.

If you discover you have stray elements or you missed part of your selection, use the Undo feature in Handy Photo to go back and adjust your selection, then Move again. You can go back and forth through this proce-dure, fine-tuning the selection and reviewing the results on a blank background until you are ready to commit the Move by saving the image to the Camera Roll.

The End Result

At the end of this procedure you have an image of a specific element, with either a transparent or white back-ground, which can be processed further in editing apps or combined with other layers in Image Blender.

Cut, Invert, and Layer: Frame

Once you cut an element out of a photograph, you can use that new element in different ways. In the image *Aspens*, a cut-out leaf became a frame for another photograph.

Image Selection

In its original photograph, the leaf was included as a whole shape, in sharp focus, and delineated from the other elements. These were the key features that made it easy to cut.

Selecting the Element

Starting with Handy Photo, I cut out the leaf, placed it on a white background, then converted it to black & white in Snapseed. I increased the contrast in the black & white version so the vein detail in the leaf would be retained when I later blended this image.

Invert the Image

The next step was to invert the black & white leaf image (making the white areas black and the black areas white). A few apps offer functions that invert color, such as FX Photo Studio and XnView Photo FX—but there is also a simple way to do this using Image Blender. Load the black & white image as the bottom layer and a plain white background as the top layer. After choosing the Difference blending mode, slide the opacity to 100 percent and the image is inverted.

Blending

To finish, I blended the inverted image as the frame (the top layer) with another processed image of aspen trees (the bottom layer) using a darkening mode at high opacity. For *Aspens*, the darkening mode I chose was Multiply with an opacity of 100 percent.

▲ Original leaf photograph.

▲ Cut out leaf.

▲ Inverting in Image Blender.

▲ Bottom image.

▶ **FACING PAGE** – *Aspens* ● ProCamera, Handy Photo, Image Blender, Snapseed, AutoPainter II

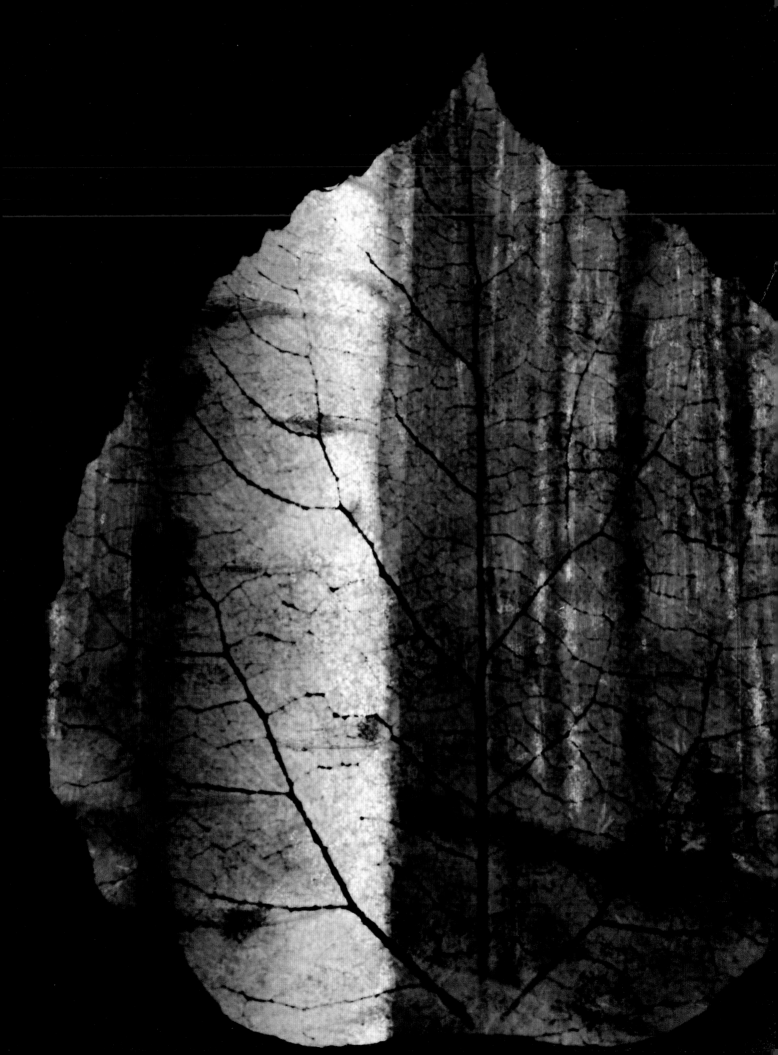

Cut, Invert, and Layer: Background

▲ Circle Frame from Afterlight.

▲ Arrange and Invert in Image Blender.

▲ Blended with texture.

▲ Final background.

◀ Tree image.

With the techniques in this book, you have the tools needed to craft alternate realities for your photographs. You can take a photograph in broad daylight and make it look like it was sunset, deepest midnight, or even outer space. The photograph is the raw material for a new creation. *Harvest Moon* is an example of how simple editing techniques can be used to suggest an experience—in this case, viewing the moon through a tree—on a scale that would be impossible to photograph.

Afterlight: Cutting a Circle

To create the moon, I cut a circle shape from a previously created background. I use the frames in the Afterlight app to cut out perfect shapes, such as circles. By setting the frame color to white, it's as if I cut and layered the shape onto a white background.

Image Blender

Afterlight centers the shape frame, so I used Image Blender and a white background to arrange the shape off the edge in an artistically pleasing way. I also used Image Blender to invert the image, as described in section 56.

Background Texture and Color

To alter the color, the black background had to be lightened, so I blended it with a texture layer in Image Blender. I

Harvest Moon ● ProCamera, Afterlight, Snapseed, Stackables, Image Blender

finished the background by processing it with multiple layers in Stackables, creating the color variations.

The Tree Image and Final Details

To create the tree image, I converted an original photograph to black & white with high contrast. Note that the direction of the light in the tree image serves to reinforce the impression of moonlight, since the moon is on the right side of the image.

When blending multiple images together, small details such as the direction of the light become important. To create an alternate reality that engages the viewer, it helps if the image has elements that are grounded in real experience.

Paper Cutout Effect

aking things a little further out of reality, you can use a silhouetted photograph as means to create the effect of cut-out paper. *Sing Me a Blue-Green Moon* combines three elements: a created background, a photograph of trees, and the circle shape background created for *Harvest Moon* (section 57).

The starting tree photograph, captured on a morning hike in the forest, bears little resemblance to the ending image. A high-contrast, black & white image is re-

quired to create a cut-out, so I cropped the forest scene, converted it to black & white, and edited it to create a simple silhouette.

To achieve the paper cut-out effect in Image Blender, I placed the silhouette as the bottom layer and the created background as the top layer, then blended them using Hard Light mode.

Before combining the paper cut-out with the moon background, I converted the moon image to blue tones in Stackables. Then I blended the cut-out (bottom layer) and the moon background (top layer) in the Darken mode. In this blend, the trees were masked so the moon would not show through.

The blue tones of the background and foreground did not quite match, so my last step was to process the blended image in Stackables and create a harmonious blue-green color palette across the combined elements.

▲ Starting tree photograph.

▲ Converted to silhouette.

▲ Paper cut-out.

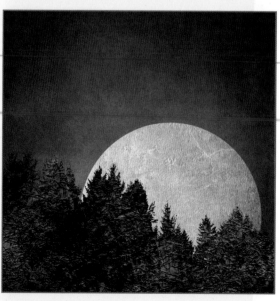
▲ Cut-Out Blended with background.

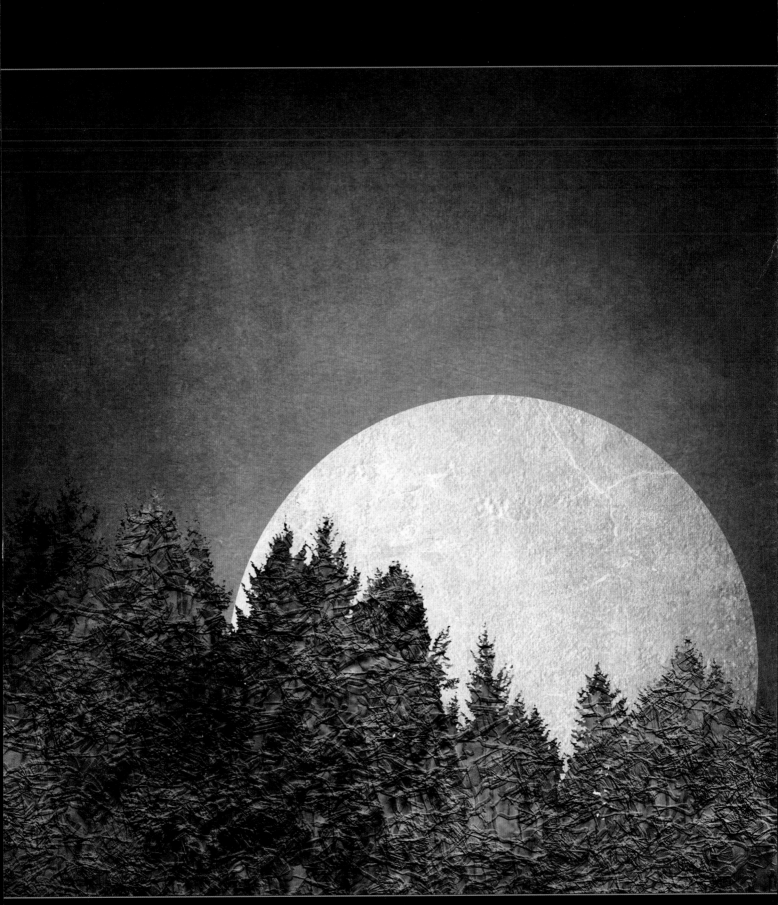

Sing Me a Blue-Green Moon ● ProCamera, Snapseed, Afterlight, Image Blender, Stackables

Bleeding Paint Effect

Are you convinced yet of the magic of blending? You can use it for so much beyond textures, taking your photographs into new creative realms. Let's finish out the advanced examples with *From One Season to Another,* which demonstrates how experimenting with blending sequences can lead to unique artistic styles.

It starts with a photograph of—what else?—a tree. I was attracted to the variations in color of the autumn leaves. The first post-processing step was to brighten

and enhance the color in Snapseed. Next, the photograph was processed through several apps, providing the base images for the next blending sequence.

All straightforward so far! Now, on to the exciting part. Version 2 (bottom layer) was blended with Version 4 (top layer) using the Difference mode in Image Blender. This created an interesting outlined, sketchy effect—but it's not done yet.

This step lost all of the original color, which was what attracted me in the first place. To get the color back and to further combine effects, I blended it with the Waterlogue version. Version 5 (bottom layer) was blended with version 3 (top layer) using the Lighten mode.

To complete the piece, I cropped version 6, focusing on the area of most interest, and continued through ad-

Version 1: Brighten in Snapseed.
Version 2: Version 1 through Tangled FX.
Version 3: Version 1 through Waterlogue.
Version 4: Version 1 through XnSketch.
Version 5: Version 2 blended with 4.
Version 6: Version 5 blended with 3

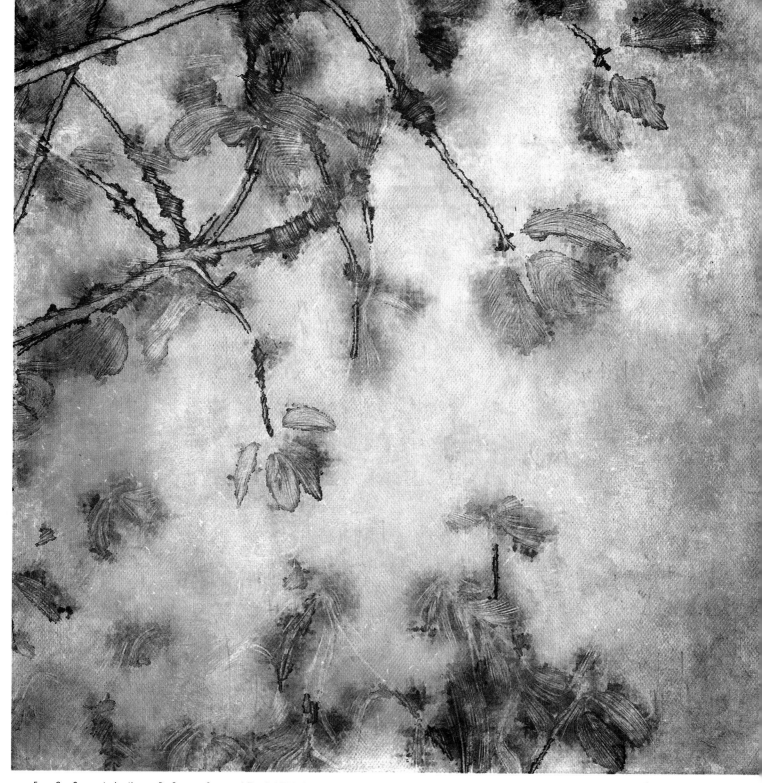

From One Season to Another ● ProCamera, Snapseed, Tangled FX, XnSketch, AutoPainter, Waterlogue, Image Blender, Stackables

ditional apps to add texture and variations in the background of the image.

The resulting effect of the blending sequence is completely unlike a photograph—and unlike the output from any one app. The delicate structure of the leaves along with the colorful, painterly bleed can only be created from this sequence of blending, discovered through experimentation. Magic!

Once you've finished creating your iPhone art, it's time get it off of your device and share it! The ease of sharing your art with others on social media, blogs, or photo sharing sites is part of the fun of iPhone photography. There is, however, one last step to consider before you share.

Protecting Your Images

Depending on the sharing service you are using, your files could be downloaded by others. For snapshots of friends, that may be no big deal—but if you are sharing art you intend to sell and want to remain attributable to you, it is good to add a watermark and reduce the resolution so that your art can't easily be reproduced as a high-quality print.

Before I share online, I use the Reduce app to reduce the image resolution and apply a watermark quickly and easily. To start out, you will want to set up the app output. From the Main Menu, set the maximum resolution, file size limits, EXIF data options, and sharpening. I typically use a setting of 700 pixels on the long side

when I share online. This size works well across multiple social media platforms and my blog.

Tap the Settings icon to add your watermark or border, if desired.

When you have updated your settings, you can apply them to a photo or group of photos. Tap the album that holds the photos you want to process. (*Note:* The Camera Roll is always the album in the top left corner.) Then tap to select your photos, and tap Start. When you go to your Camera Roll, you will see new versions with watermarks and reduced resolution. These files are ready to share online—without worry that high-resolution originals can be downloaded.

Once you get the settings where you like them, you can create a preset for future use. To add a preset, tap the Presets button, tap the Add New Preset line, type in a name for the preset, then tap Done. The preset will now appear on your list. To use the preset, select your preset by tapping on the name. A check mark appears to show you've selected the preset. When you tap the Close button, your preset settings have been applied.

◄ **LEFT**– Reduce main menu.

◄ **CENTER**– Reduce watermark menu.

◄ **RIGHT**– Reduce Presets menu.

Your Turn

You're done! Can you believe it? As you've worked your way through this book, you have gained all of the basic tools you need to create and share art with iPhone photography:

1. An understanding of the camera hardware, power, and file management techniques to keep your iPhone running well for photography.
2. Great camera apps to get the best photographs.
3. Basic editing apps to make your photographs even better.
4. Creative editing apps to alter your photographs in interesting ways.
5. Blending techniques to further transform your photographs.

Now, it's time for you to play and experiment on your own. Don't be discouraged if your photographs aren't instantly transformed into art when you use these techniques. It takes time and effort to learn the tools and develop your own style. Keep working on it. The beauty of creating art with iPhone photography is you can do it anywhere, anytime. When you have a spare moment, pull out your iPhone, take a photograph or edit one from your Camera Roll, and then share.

I'd love to see what you create! Tag your photos with #art_with_an_iPhone or @kateyeview on social media so I can find your work. You can also visit me at kateyestudio.com for ongoing tutorials. There is no end to the techniques you can learn in this new and rapidly progressing medium. Have fun creating your own altered realities!

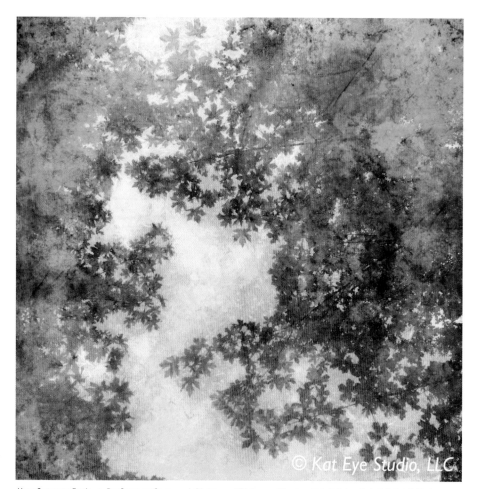

How Summer Feels ● ProCamera, Snapseed, Distressed FX, Image Blender, AutoPainter, AutoPainter II, Reduce

Photograph by Jones Oliver, iPhone edit by Kat Sloma.

Index

AmherstMedia.com

The iPhone Photographer

Unleash the power of your iPhone—and your artistic vision. Michael Fagans shows how the iPhone's simple controls can push you toward greater creativity. *$27.95 list, 7.5x10, 128p, 300 images, order no. 2052.*

ABCs of Beautiful Light

A Complete Course for Photographers

Rosanne Olson provides a comprehensive, self-guided course for studio and location lighting of any subject. *$27.95 list, 7.5x10, 128p, 220 color images, order no. 2026.*

Digital Black & White Landscape Photography

Trek along with Gary Wagner as he explores remote forests and urban jungles to design and print powerful fine-art images. *$34.95 list, 7.5x10, 128p, 180 color images, order no. 2062.*

Magic Light and the Dynamic Landscape

Jeanine Leech helps you produce outstanding images of any scene, using time of day, weather, composition, and more. *$27.95 list, 7.5x10, 128p, 300 color images, order no. 2022.*

Portraiture Unleashed

Ground-breaking photographer Travis Gadsby pushes portraiture in exciting new directions with design concepts that are sure to thrill viewers—and clients! *$34.95 list, 7.5x10, 128p, 200 color images, order no. 2065.*

Professional HDR Photography

Mark Chen shows how to achieve brilliant detail and color with high dynamic range shooting and post-production. *$27.95 list, 7.5x10, 128p, 250 color images, order no. 1994.*

Tiny Worlds

Create exquisitely beautiful macro photography images that burst with color and detail. Charles Needle's approach will open new doors for creative exploration. *$27.95 list, 7.5x10, 128p, 200 color images, order no. 2045.*

Wildlife Photography

Hunter-turned-photographer Joe Classen teaches you advanced techniques for tracking elusive images and capturing magical moments in the wild. *$34.95 list, 7.5x10, 128p, 200 color images, order no. 2066.*